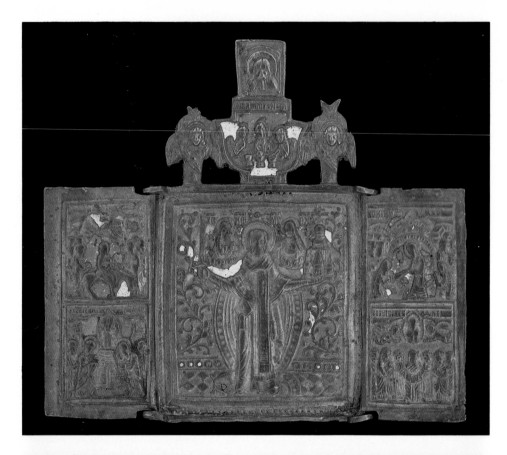

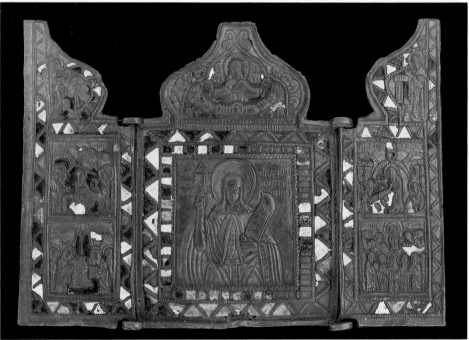

FRONTISPIECE.—Above, triptych with crest and finial depicting Saint Nicholas of Mozhaisk, Kunz collection number 25819.088; below, triptych with crest depicting Saint Paraskeva Piatnitsa, Kunz collection number 25819.057.

SMITHSONIAN STUDIES IN HISTORY AND TECHNOLOGY • NUMBER 51

Russian Copper Icons and Crosses from the Kunz Collection: Castings of Faith

Richard Eighme Ahlborn
and
Vera Beaver-Bricken Espinola

EDITORS

SMITHSONIAN INSTITUTION PRESS

Washington, D.C.

Library of Congress Cataloging-in-Publication Data
Russian copper icons and crosses from the Kunz Collection : castings of faith / Richard Eighme Ahlborn and Vera
Beaver-Bricken Espinola, editors.
 p. cm. — (Smithsonian studies in history and technology ; no. 51)
Includes bibliographical references.
1. Icons, Russian. 2. Crosses—Russian S.F.S.R. 3. Copperwork—Russian S.F.S.R. 4. Christian art and
symbolism—Modern period, 1500– —Russian S.F.S.R. 5. Kunz Collection. 6. Icons—Washington
(D.C.) 7. Crosses—Washington (D.C.) I. Ahlborn, Richard E. II. Espinola, Vera B. III. Kunz Collec-
tion. IV. Series.
NK1653.S65R8 1990
730'.947—dc20 90–19630

ISBN 1-56098-068-0

This publication is the trade edition of Smithsonian Studies in History and Technology, 51.

COVER IMAGE: Icon: Four-leaves with crests, depicting Church Feasts; Kunz collection number 25819.055.

Contents

Dedication

This publication is dedicated to the memory and contributions of
Dr. Anton S. Beliajeff, advisor, scholar, and respected colleague.

Russian Copper Icons and Crosses from the Kunz Collection: Castings of Faith

Introduction and Acknowledgments

Richard Eighme Ahlborn

In 1891, when George Kunz, agent for Tiffany and Company of New York, traveled to the annual fair in Nizhnii Novgorod, Russia, in search of gem stones and arts for his employer and private American clients, in part, he was responding to a well-developed American interest in Russian culture, a fragment of a vast fascination with "the exotic East."

Those vague lands, stretching from China to Arabia to Russia, were romanticized by better-educated Americans who were fleeing the grim reality of urban slums and unsafe factories. As American industrial and economic expansion continued, exposure to Eastern cultures fed American imagination, and an acquisitive spirit.

Oriental porcelains and prints, Persian poetry and rugs, and Russian metal wares, enamels, and novels were welcomed into the late Victorian parlor. In the concert hall, Russian symphonies, ballets, and operatic themes created bold patterns and lyric richness to fuel the mechanism of exoticism.

With Russia long out of Alaska and the Romanovs living out an illusion of regal authority, privileged Americans began to indulge themselves by collecting Russian furs, gem stones, and encrusted metallic crafts of the late nineteenth century. Kunz responded to this market for exotic Russian arts with regular journeys into that vast empire. But it was the collection Kunz made of 350 copper-alloy traveling-size icons that fulfilled the Smithsonian Institution's need for objects representative of religious and ethnographic studies. The icons were collected as documents of the popular maintenance of Eastern Orthodoxy through its 900 years among the eastern Slavs, with particular relevance to the Russian "Old Believers." They perpetuated rites and practices that were abandoned by the church reforms of the late seventeenth century, and they continued to make copper-alloy (e.g., brass and bronze) icons and crosses even after Peter the Great's 1723 ban on their manufacture or use.

The fifty metal icons and crosses displayed in the National Museum of American History in 1988 are representative of the collection of more than three hundred. All but two of these fifty copper-alloy castings came to the Smithsonian Institution in 1892. That year, the Smithsonian's Assistant Secretary, G. Brown Goode, received an offer from George Kunz concerning a sizeable collection of icons he had acquired at the August fair at Nizhnii Novgorod, Russia.

Lacking funds to purchase the entire lot, the Smithsonian acquired what it could in 1892. In the following decades, the metal icons were stored away and studied as part of a general scholarly interest in comparing world religions. Several were described and illustrated in a posthumous publication of Smithsonian Assistant Curator Immanuel Moses Casanowicz (1929).

It was not until 1981, however, that a thorough survey was undertaken of the metal icons and crosses at the urging of an American-born professional conservator and student of old Russian culture, Mrs. Vera Beaver-Bricken Espinola. She meticulously examined, re-numbered, cleaned, and re-housed all the metal icons; the most unstable received full conservation treatment. Supported by her Russian Orthodox and Old Believer heritage, Vera Espinola brought her linguistic abilities, analytical skills, and colleagues in Soviet and American academic communities to focus on the Smithsonian Institution's metal icon collection. As a result, a new research and public education project came into being in 1985.

The "Russian Icon Project" received the benefit of a

Richard E. Ahlborn, National Museum of American History, Smithsonian Institution, Washington, D.C., 20560.

scholarly Advisory Committee, invited by the Director of the National Museum of American History, Roger G. Kennedy. Committee members consisted of Dr. Anton S. Beliajeff, historian of the Orthodox church and the Old Believers; Prof. Nicholas V. Riasanovsky, scholar of Russian history; Mrs. Vera B. Espinola, conservator; Mr. Basil Lefchick, iconographer; Fr. Dmitri Grigorieff, Orthodox theologian; Dr. Richard Morris, anthropologist; and the co-editor, a curator of Christian artifacts at the Smithsonian Institution.

By January, 1988, the Project planning included a display of representative metal icons and crosses, a brochure, a one-day symposium, and this publication. Earlier, specialists of Ukranian Orthodoxy confirmed that the collection contained no Ukranian objects. Vera Espinola selected fifty icons and crosses for display, and each was carefully photographed at the Smithsonian by Dane Penland. Later, additional icons were photographed by Charles Rand, Collections Manager for the Smithsonian's National Numismatic Collection. At a series of meetings beginning in 1981, members of the Advisory Committee set out to write essays for this publication and to raise funds for the exhibition and publication of the catalog.

Funding for the Russian Icon Project benefitted greatly from private interests. Marinka Bennett established the special project fund with its most substantial contribution. Subsequent support was generously given by The Congress of Russian Americans, Inc., Vera B. Espinola, The Association of Russian-American scholars in the USA, Inc., Marion R. Koehler, Natalia Solzhenitsyn, and Vladimir and Suzanne Tolstoy.

The Russian Icon Project drew on the expertise of numerous scientists and scholars. These specialists have contributed directly to the Icon Project and are gratefully acknowledged for their generosity, skill, and knowledge: Gary Carriveau, Paul Angiolillo, and Lisha Glinsman of the Scientific Department, National Gallery of Art; Tom Chase of the Freer Gallery of Art and Sackler Gallery, who prepared Table 1; Robert Organ, retired, Martha Goodway, Walter Hopwood, and Joan Mishara of the Conservation and Analytical Laboratory, Smithsonian Institution; Scott Odell and the staff of the Division of Conservation, National Museum of American History; Pete Dunn of the Department of Mineral Sciences, National Museum of Natural History; Karen Preslock, Chief Librarian, Library Research Services Division, Smithsonian Institution; Robert Brill of the Corning Museum of Glass; John Patrick, who reviewed early drafts of the manuscript; David Osborne and Boris Boguslavsky of the Library of Congress; ethnologists Larisa Romanovna Pavlinskaya, Sergei Iakovlich Serov, and Alexander Ivanovich Teryukov of the MAE Ethnographic Institute and USSR Academy of Sciences; Marina Sergeiivna Shemahanskaya, Head of the Metals Conservation Laboratory, All-Union Scientific and Research Institute for Restoration, Moscow; and Maria Danilovna Malchenko and Sergei Vladimirovich Tomsinsky, curators of the Kalikin collection of metal icons and crosses at The Hermitage Museum, Leningrad. These Soviet scientists, as well as Mikhail Ivanovich Chuvanov, Chairman of the *Preobrazhensky* Community of Old Believers, granted personal interviews to Vera Espinola between 1980 and 1987.

Russia, 1600–1900

Nicholas V. Riasanovsky

This segment of Russian history possesses a certain unity, for it largely overlaps the imperial, or Petrine, period in the evolution of Russia.

The empire of the Romanovs began formally in 1721, when Peter assumed the title of emperor, or, if one prefers, two or three decades earlier when he became the effective ruler of his country. The empire continued until 1917. Yet, the respected Russian historian Kliuchevsky and many other specialists regarded the seventeenth century as a period of transition, perhaps even more significant in certain major ways than the hectic years of the Petrine reform. The seventeenth century witnessed a slow and uneven "Westernization" of Moscovy, Moscovy expansion into the Ukraine, the final stages of the creative development of numerous elements of old Russian culture, and the only fundamental split in the history of the Russian Orthodox church (which separated the so-called Old Believers from the religious mainstream), a split that was itself connected to the new ideological and cultural currents of the time.

The transition was a major one. Skipping the Renaissance, the Reformation, the sequence of overseas discoveries, and the scientific revolution, so prominent in Western history, Russia, or rather the Russian ruling circles and the very small but growing Russian educated public, moved out of the quasi-medieval, church-centered world of Moscovy and into the European eighteenth-century Enlightenment as a result of the Petrine reforms. Not surprisingly, the nature and import of the Petrine reforms remain a crucial issue of Russian historiography.

Possibly the best approach to that issue is to distinguish various aspects of Russian history and the changes resulting in those aspects. Peter the Great succeeded in modernizing the army and creating a fine navy. Indeed, he defeated Sweden in the decisive Great Northern War (1700–1721), gaining for Russia a permanent position as a major European and even world power. However, it is generally agreed that Peter the Great did not transform either the Russian economy or Russian society. The administration and political structure in general in Russia suggests a more complex picture. The establishment of

Nicholas V. Riasanovsky, Department of History, University of California at Berkeley, Berkeley, C.A., 94720.

the Senate, the Holy Synod, the colleges, the new provincial administration, and the Table of Ranks, together with numerous other related reforms, gave Russia a novel, and unmistakably Western, political structure. State-sponsored and irreversible intellectual and cultural transformations brought parochial and religious Moscovy into the universalist and secular Age of Reason. However, a question remains about the extent to which the Western style reforms changed, then and subsequently, the old Moscovite practices of largely personal and arbitrary official action.

By most measures Russia proceeded to do well in its new role. Peter the Great's triumph over Sweden was followed later in the century by Catherine the Great's sweeping victories over Turkey and her crucial participation in the three partitions of Poland, which eliminated that unfortunate state from the map of Europe. (Catherine, who ruled Russia from 1762 to 1796, was originally a German princess devoted to the Enlightenment and with no Russian roots whatsoever.) Educated Russians continued to learn from the West and began to produce outstanding writers and other intellectuals and artists of their own. The cosmopolitan imperial Russian court in St. Petersburg, the city founded by Peter the Great, was fast becoming a leading center of the aristocratic culture and society of Europe. The city itself, principally a late eighteenth and early nineteenth century creation, remains one of the world's treasures. Even in such industrial items as the production of pig iron, Russia, prior to the development of the industrial revolution in Europe, made an impressive showing.

The first half of the nineteenth century proved to be less fortunate for the empire of the tsars. Although eventually victorious over Napoleon, Russia assumed a defensive and static stance, particularly during the thirty-year-long reign of Nicholas I, 1825–1855. Unwilling to compromise the age-old but increasingly archaic key institutions of autocracy and of serfdom, the government tried certain palliatives and resorted to increased regimentation and control. Meanwhile, other European countries developed politically and, especially, progressed economically and technologically. Russian blunders in foreign policy added their contribution; the result was the disaster of the Crimean War, 1853–1856.

The inevitable reforms came shortly after, featuring the emancipation of serfs (half the peasant population of Russia;

3

the other half consisted of peasants on state lands) in 1861, followed by basic changes in the judicial system, local government, and the military. The emancipation has been said to be the greatest legislative act in history, meaning all human history; nor can the other "great reforms" in Russia be considered anything but major. But major did not necessarily mean successful. The problems of the mostly illiterate and chronically poor masses remained and even increased with the rapid growth of population, even to the point of large numbers starving because of drought as late as the 1890s. The emancipation reform included such questionable provisions as redemption payments for the land, which the former serfs did not meet, and the granting of the land in much of European Russia to peasant communes that stifled individual initiative. Large industry and the working class, in one word, capitalism, began to develop. A middle class began to emerge and so did the professions. The legal profession was in effect created by the reform of 1864. But all that development meant new difficulties and new tensions as well as new opportunities. With important accomplishments and rapid progress, but also with huge problems, obstacles, and mistakes, it remained difficult to predict whether the imperial Russian system had within itself the capacity to survive. After 1914 the added burden of the First World War made the verdict moot.

For those interested in icons the most important divide is at the beginning of this account, when Russia, or rather the Russian government and leading circles, switched from their traditional religious culture to the modern secular one. Of course, imperial Russia remained officially Orthodox, just as other European states were officially Lutheran or Anglican. The link between the state and the church was, in fact, uncomfortably close. Nor was the new culture, whether one thinks of the Slavophiles or of Dostoevsky, unaffected by its Orthodox background. Still, one of the most direct legacies of the earlier and more religious age, so well symbolized by icons, remained in the churches and huts of the common people. It is with this fundamentally spiritual legacy that the government of the land will have to contend, in the days of Gorbachev and *glasnost*, and thereafter.

Russian Orthodox Theology and Icons, 1600–1900

Fr. Dmitry Grigorieff

Icons are perhaps the most eye-catching objects identifying the Eastern Orthodox faith from other Christian denominations. They are the first thing one sees upon entering an Orthodox church. They are prominently placed in the homes of Orthodox Christians. They grace the glossy pages of gift albums studying Byzantine and Russian medieval art.

Icons, usually paintings on wooden boards, but also murals, or embossments on metallic surfaces, are organically connected with life and the teaching of the Orthodox church.

Historically, the Orthodox church descends directly from the Christian church of the first centuries. It claims that it has preserved intact the dogmas and the Apostolic tradition rooted in the Holy Scriptures as defined by the Holy Fathers[1] and the Ecumenical Councils. These dogmas and traditions, including veneration of icons, were accepted by Christianity before the split between Eastern and Western Christendom became final in the eleventh century. The schism occurred along the lines of division of the ancient Roman empire into two parts, the Western with its center in Rome and the Eastern with its center in Constantinople.

Orthodox worship is an intricate combination of spiritual intensity and sensual perception. It is based on belief in the inseparable link of the spiritual and material aspects of humanity and the mystery of the Incarnation. The Lord became man, walked among the people, entered the stream of Jordan, blessed the bread and wine, and thus began the sanctification and transfiguration of the fallen world and its return to the Father. The divine process continues in the Church. The Orthodox believe that everything around them can be sanctified and serve to glorify God, including voices, gestures, poetry, fragrances, and colors.

The idea of the icon is rooted in the concept of the Incarnation. Father A. Schmemann wrote the following:

No one has ever seen God, but the Man Christ reveals Him in full. An image of the Man Jesus is therefore an image of God, for Christ is the God-Man. If the material universe and its matter can be sanctified by the grace of the Holy Spirit, and in feeding our bodies also the "whole man" in God's conception of him as an incarnate spirit; if the water of baptism grants us forgiveness of sins; if the bread and wine of the Eucharist make present to us the Body and Blood of Christ, then a portrayal of Christ, the product of human art, may also be filled with the grace of His presence and power—may become not only an image but also a spiritual reality. In the icon there is at once a further revelation of the profundity of the dogma of Chalcedon [Fourth Ecumenical Council in 451 A.D. at which the Christian dogma of the Incarnation was affirmed, D.G.] and the gift of a new dimension in human art, because Christ has given a new dimension to man himself.[2]

Not only Christ's image may be painted on an icon. Every saint is a witness for Christ and His image. According to the Orthodox faith, their example has to be emulated by individuals in a constant effort of spiritual and moral self-perfection. In fact, every man carries the image and likeness of God in himself, which is tarnished and darkened by sins.

I am the image of Thine ineffable glory, though I bear the brands of transgressions. Pity Thy creature, O Master, and purify me by Thy loving kindness.[3]

According to Orthodox tradition the original icon was an "image not made with hands" of the Savior. The ancient legend tells how King Augar of Edessa in Asia Minor heard about Christ, believed in Him and wanted to have His image. He sent an artist to Christ to make a portrayal. The artist was unable to catch the features of Christ's face. Seeing his embarrassment Jesus applied a cloth to His face and His image was left on it.

There is a parallel story of "Veronica's Veil" in the Western tradition. A woman of Jerusalem, Veronica, filled with compassion at the sight of Jesus' suffering on His way to Calvary, wiped His sweating face with a cloth and His image remained there on the cloth.

It is not the facts that are important in these stories or parables, but their references to the metaphysical connection of the divine and the human in the concept of iconography. Icons may be beautiful examples of artistic creativity. But they also are windows into the other world. The iconographer attempts to catch the innermost spiritual essence of a particular person, or an event (e.g., the Nativity) rather than external reflections of life.

Besides its aesthetic value and its attempt to express visions of the world and life through specific artistic forms, icons may contain a deep theologico-philosophical meaning. This is particularly characteristic of Russian medieval religious art. Russian religious experience and mind were expressed considerably more in iconography and church architecture than in

Dmitry Grigorieff, Russian Orthodox Church of St. Nicholas of the Orthodox Church in America, 3500 Massachusetts Avenue, Washington, D.C.

written theological works. Father George Florovsky pointed this out:

> ...the Russian icon irrefutably testifies to the complexity and profundity, as well as to the genuine beauty, of old Russia's religious life. With justice Russian iconography has been described as a "theology in colors."[4]

The icon of the Holy Trinity by Andrei Rublev, the foremost Russian iconographer, is probably the best example of Russian medieval iconography and its link with theology and philosophy. Painted around 1408 by the venerable artist for the Trinity Monastery of St. Sergius of Radonezh in the place presently known as Zagorsk, it is now kept in the Tretyakov Art Gallery in Moscow.

There is a remarkable and revealing interrelation between the monastery, which became the center of Russian culture and spirituality, the Holy Trinity icon, and Russian medieval iconography. St. Sergius dedicated his monastery to the Holy Trinity, which for him was an image of transfiguration and unity of all creatures in God. The same ideal inspired old-Russian piety and iconography. "Overcoming of the ugly divisiveness of the world, the transfiguration of the universe into a temple, in which the whole creation is united in the same way as the three persons of the Holy Trinity are united in one Divine Essence, is the basic theme to which everything is subordinated in the old-Russian painting,"[5] wrote Prince Eugene Trubetskoy (died 1920), whose studies of the old Russian icons from artistic, theological, and historical angles are still unique.

By an already existing tradition, Andrei Rublev depicted symbolically the Holy Trinity as the three wandering angels who appeared to Abraham by the oak of Mamre (Genesis 18). "The angels, seated at a low table, form such a closely knit group that it is impossible not to interpret it as embodying the ideal of peace and harmony."[6] [For a similar treatment of this concept see description of icon 25819.225 on page 72. R.E.A.]

Through the colors and composition of the icon a bright sadness emanates from the angels to something below them. St. Sergius, when he built his monastery church of the Holy Trinity in the dense forest, prayed that the cruel world surrounding him, divided by hatred and derisions, would be filled with the love and harmony reigning in the pre-eternal council of the triune God.

Prince E. Trubetskoy points out the contradictory impressions often made by the simultaneous coexistence of cheerfulness and asceticism, joy and sadness in the icons. "However," he writes, "there cannot be Pascha (Easter) without the Passion week and one cannot bypass the life-giving cross of the Lord on the way to the joy of the universal resurrection. Therefore the joyous and sad, ascetic motives are equally indispensable in our iconography."[7] Also, the icon is an image of a future transfigured humanity, which we do not see around, but are just trying to perceive with our inner spiritual sight. The ascetic thinness of human features in the icons is directed against the principle of biologism and the primacy of flesh in our society.

It attracts our attention beyond our world filled with bloody struggle for material goods to the new form of life in the Kingdom of God, which "flesh and blood cannot inherit" (I Corinthians 15:50).

The icon does not fail to embrace space in accordance with optical laws simply because artists were not skillful. The lines in their perspective, instead of crossing in the horizon, deliberately cross in the spectator himself. Everything in the icon, including perspective, facilitates the transfer of the spectator's mental perception from the world of phenomenon to the mystical dimension of Orthodox theology.

The iconoclastic movement in eighth century Byzantium originated in some subtleties in church-state relations, in secular and ecclesiastical cultural contacts, in Islamic bans on human images and Hellenic "spiritualism," but probably most of all in some popular serious distortions of icon veneration resembling idol-worship. The prohibition against icons by imperial decree lasted over fifty years until the Seventh Ecumenical Council in 787 A.D. restored their veneration. Actually, the iconoclastic persecutions prompted the church to creatively rethink the whole problem and to come up with more lucid and substantial explanations of the icon. Much was done to clarify the dogma of the veneration of icons before the council by St. John of Damascus, a monk in the monastery of St. Sabbas in Palestine.

> In former times God, who is without form or body, could never be depicted. But now, when God is seen in the flesh conversing with men, I make an image of the God whom I see, I do not worship matter; I worship the creator of matter who became matter for my sake, who willed to take His abode in matter; who worked out my salvation through matter. Never will I cease honoring the matter which wrought my salvation. I honor it, but not as God.[8]

St. John's theology of the icon is based on the Incarnation of Christ and so is the dogma promulgated by the Seventh Ecumenical Council.

The iconoclasts were afraid of idol-worship in the icons. However, there is a sharp distinction in the Orthodox tradition, between the words "veneration" (*proskinesis* in Greek, *pochitanie* in Russian) and "adoration" (*latreia* in Greek, *poklonenie* in Russian); the latter may refer to God only. However, both Greek terms, *proskinesis* and *latreia* were translated in Latin as *adoratio*. This caused a lack of understanding of the theology of icons by Latins, and in the West in general.[9]

There has been a marked decline in Orthodox iconography in the last three centuries. The influence of the Renaissance and Humanism upset the delicate balance of the spiritual, theological, and material elements of the iconographic tradition, and rather dull, realistic pictures, devoid of lofty symbolism and spiritualism, started to appear everywhere. Only the Old Believers, oppressed by the state authorities, preserved the tradition. Fortunately with the beginning of this century, a revival of the traditional church art has appeared. And that is an incalculable gift to the millennium of Russian Christianity.

Notes

[1] The most important among the Fathers are St. Basil the Great, St. Gregory of Nasianzen, St. Gregory of Nyssa, St. John Chrysostom, St. Athanasius of Alexandria, St. Cyril of Alexandria, St. Maximus the Confessor, St. John of Damascus, and St. Gregory Palamas, Archbishop of Thessalonica.

[2] A. SCHMEMANN, *The Historical Road of Eastern Orthodoxy,* translated by L. Kesich (New York: Holt, 1963), page 202.

[3] From the Orthodox Service For the Departed.

[4] G. FLOROVSKY, *Ways of Russian Theology,* translated by R. Nichols (Belmont, Mass.: Nordland, 1979), page 1.

[5] PRINCE EUGENE TRUBETSKOY, *Oumozrenije v Kraskah* (Paris: YMCA Press, 1965), page 20.

[6] ANONYMOUS, *Russian Icons from the Twelfth to the Fifteenth Century,* Introduction by Victor Lazarev (New York: Mentor-Unesco Art Book, 1962), page 20.

[7] Trubetskoy, op. cit., page 22.

[8] ST. JOHN OF DAMASCUS, *On the Divine Images,* translated by D. Anderson (Crestwood, N.Y.: St. Vladimir's Seminary Press, 1980), page 23.

[9] *See* I. MARKADE, "Ikona kak zerkalo trisolnechnogo sveta pravoslavija," *Novyj Zhurnal* (New York), number 3, 1979, page 180–189.

Copper Icons in Daily Use in Old Russia

Vera Beaver-Bricken Espinola

Copper icons were attached to grave markers, as illustrated by those nailed to wooden posts (Figure 1) in a nineteenth century Old Believer cemetery in northern Russia.[1] A more modern example is a brass crucifix secured to an elaborately carved post on the 1927 grave of the renowned Russian artist Boris Mikhailovich Kustodiev, in the St. Alexander Nevsky

Vera B. Espinola, National Museum of American History, Smithsonian Institution, Washington, D.C. 20560.

cemetery in Leningrad. This type of old Russian post, with a little roof called a *srub,* was traditionally placed at the foot of the grave (Figure 2).

Many of the icons and crosses in the Smithsonian's Kunz collection have bent edges and wings and round holes in the metal. Nails were driven through the metal itself, wedged between the wing and panel of a triptych, or bent over a panel. One icon of St. Nicholas (25819.227) still shows a rust stain from such a nail on its bent edge.

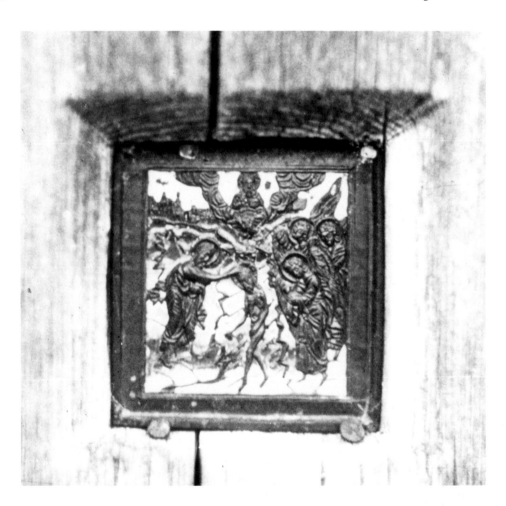

FIGURE 1.—Metal and enamel icon nailed to a grave marker in an Old Believer cemetary in northern Russia. (Courtesy of Alexander I. Teryukov, photographer)

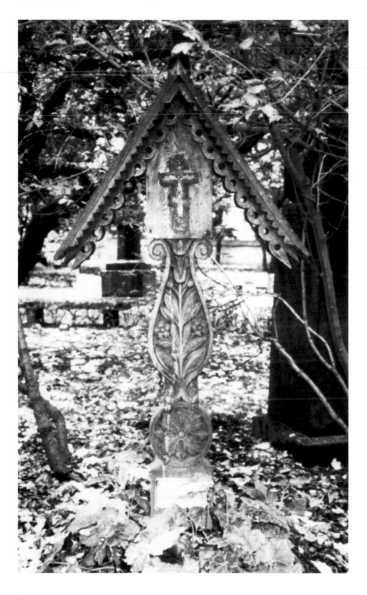

FIGURE 2.—Wooden grave post and srub, with attached metal crucifix. (Vera B. Espinola, photographer)

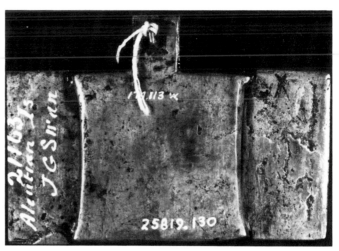

FIGURE 3.—The back of triptych 25819.130 showing suspension loop and the remains of a twisted cord. (Photographer Smithsonian Institution or Vera B. Espinola)

Almost all of the earlier icons in this collection have holes in the crests for suspension. Thin cords, often coated with resin for strength, were used to hang small icons and pectoral crosses around the neck. The remains of such a twisted string can still be seen in the crest of triptych 25819.130 (Figure 3).

Copper icons and crosses were objects of veneration and were kissed, incensed, and had oil lamps and candles burned before them. Some from the Kunz collection have old candlewax deposits that have turned green from over one hundred years of contact with the copper.

If the eyes of the metal figures were worn and could not "see," then these objects were no longer used for veneration. Icons and crosses were not thrown away, but when smooth, they were disposed of by burial in the ground or in a body of water, sometimes wrapped in a cloth.[2] Many of the icons nailed to cemetary posts also had worn faces indicating another method of retiring icons that could not "see." These methods of disposal were practiced because of individual or regional reverential custom, which were neither demanded by religious function nor by church dogma. During Peter I's reforms, a resolution passed on 29 March 1721 stated that objects originating from the *raskolniki* (referring to the Old Believers as schismatics) should be thrown either into water or into fire.[3] Many icons and crosses in the Smithsonian's Kunz collection are heavily impacted with silicious material, an indication of burial. Fire-rounded grains of sand were identified as quartz and feldspar.[4] Interspersed with this material were occasional red textile fibers, white textile fibers, and sometimes bits of wood and charcoal.

Icons from the Kunz collection were known as "travelling icons" and the Reverend W. Sparrow Simpson[5] wrote in 1867 about twenty-nine similar icons that were brought to England after the Crimean war:

When a peasant is about to send his son to service in the Army, he often takes from his neck the icon that he and his forefathers have worn, and places it, with his benediction, on the young soldier's breast. To the soldier himself the icon becomes a memento of his country, of his family, of his religion. Of his country, because it usually bears the effigy of some Russian saint, very frequently, the patron saint, S. Nicholas; of his family, for this icon may have been an heirloom; of his religion, for when about to offer his prayers, he opens his triptych or diptych, and kneels before it as a portable altar. He carries it, suspended round his neck, through the vicissitudes of a campaign; and when, his labours ended, he returns to his native parish, he often hangs his cherished possession upon the iconostasis of his village church, as a votive offering to commemorate his preservation.

Notes

[1]Personal conversations (March, 1986, and September, 1987) with Alexander Ivanovich Teryukov, ethnographer, Institute of Ethnography, USSR Academy of Sciences, Leningrad. Icons were found buried in the ground above the deceased in this cemetery. Sometimes they were found lying on the surface where they had fallen from posts. Alexander Teryukov took color slides of nineteenth century Old Believer cemeteries in Northern Russia (R.S.F.S.R.) in 1979.

[2]Personal conversations (Moscow, April, 1980, and September, 1987) with Mikhail Ivanovich Chuvanov, chairman of the Transfiguration (*Preobrazhensky*) Community of Old Believers in Moscow and co-editor of the Church Calendar of the Bezpopovtsy Old Believers. A renowned scholar and bibliophile, he is said to have the most complete collection of rare Old Believer books as well as works of Holy Scripture and works by Church Fathers and teachers such as SS. Augustine, Basil the Great, and John Chrysostom. In 1987, Mikhail Ivanovich was ninety-seven years young and active in his work. He died in April, 1988, after a short illness.

[3]M.N. PRINTSEVA, "K Voprosu ob Izuchenii Staroobryadcheskovo Mednovo Litya v Muzeinikh Sobraniyakh," *Nauchno-Ateisticheskiye Issledovaniya v Muzeyakh,* Izdaniye GMIRiA, Leningrad, 1986, page 51.

[4]Mineral identification by Dr. Pete Dunn, Department of Mineral Sciences, National Museum of Natural History, Smithsonian Institution, 1983. In 1982, Dr. Robert Brill of the Corning Museum of Glass examined the sand on 12 representative icons and stated that the edges of some of the quartz and feldspar are fire-rounded.

[5]REV. W. SPARROW SIMPSON, "Russo-Greek Portable Icons of Brass" *(The Journal of the British Archeological Association*, London, June 30, 1867), page 114.

Icons Amidst Russian Old Believers of Oregon and Alaska

Richard A. Morris

Among the Slavic peoples of the United States are some 6,000 Russian Old Believers. Of recent immigration, they have settled in Oregon and Alaska to live, work, and raise their families according to the pre-seventeenth-century rite of the Russian Orthodox church. As a traditional religious group, their beliefs and practices give an important historical insight into the place and role of Orthodox icons in America.

The Old Believers presently living in Oregon and Alaska began arriving in 1964 from various parts of the world in search of a place where they could preserve their religion and way of life. They first settled in the mid-Willamette Valley, an agriculturally rich, rural region in western Oregon. Later, several families decided to move to Alaska, where they purchased a square mile of land on the Kenai Peninsula. The village they founded attracted other Old Believers and has grown to some 70 families, approximately 600 people.

Over the centuries, Old Believers have characteristically sought remote, isolated regions where they could establish a village, build a prayer hall, and become a self-sufficient community. Insulated from the surrounding society, they were free to practice their religious convictions and way of life. For some 330 years, the faithful adherents have survived, scrupulously holding to the Old Rite that was prevalent until the Church Reforms of 1651–1667.

The Church Reforms, instituted by Patriarch Nikon in the mid-seventeenth century, revised church books and elements of the Service ritual. Many people of the day interpreted the reforms as sacrilegious, and refused to accept them. Nonetheless, Tsar Alexei approved the reforms, and by doing so, alienated large segments of the faithful from their church and crown. This period in Russian history has become known as the Great Schism, or *Raskol*. Those who insisted on keeping the Old Rite became known as Old Ritualists, or, Old Believers.

Old Believers in old Russia were periodically persecuted, and occasionally cajoled or forced to rejoin the dominant Orthodox church. But despite persecutions, subsequent political turmoil that has pushed many of them from their homeland, the adversities of successive migrations, and the need to accommodate their religious services to circumstances that

would not permit the full practice of the Old Rite, Old Believers have persisted and preserved what they could over three centuries.

In Oregon and Alaska, three disparate groups of Old Believers have come together to form a larger community. Despite their experiences of a diaspora that stretched from Europe to Turkey to China, only minor differences are noted between the groups in their obedience to the Old Rite.

Through disciplined living, encouraged by their religious ethic, Old Believers have secured homes, built prayer halls, and acquired good land in Oregon and Alaska. Already they are relatively self-supporting within their families and community. In Oregon, unable to secure enough land for a unified colony, they have spread across two counties, buying farms on which to raise their characteristically large families. The movement of some families to Alaska underscores their desire to avoid contact with urbanization and its disruptive influences. There they have integrated the seasons for fishing, hunting, and planting into the rhythm of their religious calendar.

Interrelationships

The American Old Believer "villages" have regular contact with others in Canada, South America, Australia, and, less frequently, with the sizable number of Old Believers throughout the USSR. In each area, the Old Rite of Russian Orthodoxy persists.

However, the dispersion of Old Believers over three centuries has resulted in local interpretations of doctrinal issues, and differing degrees of accommodation to surrounding cultures. Members of congregations with a given doctrinal viewpoint are considered "in union" (*vmeste*), while those from congregations that practice differing interpretations would have to go through a purification, and conform to the local understandings and ways, in order to be accepted in such cases as marriage, etc.

Icons in America

An important feature of Orthodoxy involves the veneration of icons, images of holy persons. The veneration has a special intensity among the Old Believers in the United States. Icons

Richard A. Morris, Russian and East European Studies Center, University of Oregon, Eugene, Oregon.

are present in most daily activities and have a special importance at crucial events of life, e.g., marriages, blessings, funerals, and remembrances. At church services, icons venerated by the congregation encourage the worshippers to feel the presence of the personages depicted. The worshippers show respect to, and seek protection from, the personages by bowing and crossing themselves before the icons, and often kissing them.

Periodically throughout the day, prayers are made before one or another icon of the home. With their prayers Old Believers characteristically cross themselves with two fingers of the right hand. It is important to note that one of the Nikonian reforms of the seventeenth century changed the manner of crossing one's self: from using two fingers to using three fingers. This issue became an identifying symbol of resistance for the Old Believers, who still refuse to desecrate the right hand by touching the thumb to the first two fingers. [For a discussion of the seventeenth century liturgical reforms see page 31. R.E.A.]

The principle family icons are kept on a special shelf in an eastern corner of the main room. This "beautiful corner," draped with curtains, holds the family icons, illuminated by one or more oil lamps and surrounded by colored eggs. The eggs have been blessed at the previous Easter Service and carefully brought home and placed near the icons for the ensuing year. Prayers for special occasions, and before and after meals, are made before the icons. A guest to the home, upon entering, often without knocking, prays and crosses himself, bowing three times in the direction of the icon corner. The host of the house supplies the "Amen"; the guest is then welcome to greet the residents. Prior to the "Amen," no words have been exchanged. Icons are also placed in the eastern corners of other occupied rooms. In each bedroom, the occupant performs morning and evening prayers and bows toward the icon.

Narratives

There are personal stories among the Old Believers relating how an icon helped them in a moment of need, or how the mistreatment of an icon, even accidental, resulted in a problem for the individual or family involved. More frequent are the accounts in which an icon has resolved a crisis. One story retold by a woman of the Harbin group, relates how she succeeded in reaching China in the 1930s. She and her husband decided to leave the Soviet Union. On the way, her husband was arrested, and fell deathly ill in prison. She continued as they had planned, taking with her only a small, metallic icon of the Mother of God. She tied the icon to her breast as she slipped into the Amur River, which marks the boundary between the Soviet Union and China. To cross the wide river, she lay on a small board. A Border Patrol boat passed close without noticing her, but its wake caused her to lose the board. Cold and growing weaker, she clutched the icon and prayed for help. Shortly, the board appeared near her, and she was able to reach the far shore. As she tells the story, her gratitude is directed to

God, the Mother of God, and the icon itself.

Although common among the Old Believers, these stories are told only to selected listeners, i.e., people who are not likely to attempt to discredit them. Outsiders seldom receive all the details; particulars of the miraculous parts are reserved for those who will accept and respect them, usually those with whom one is "in union."

Personal Icons

A personal attachment with an icon starts at the time of marriage. Until then, the young person has been surrounded with family icons, but not one that is personally his or hers. Prior to the wedding, both sets of parents acquire an icon to give their respective offspring at the ceremony. Care is taken to find an old icon that conforms to the Old Believer style, and that might come from Old Believer hands. Otherwise, the parents can request an icon to be "written" (painted) or "poured" (cast) by one of the local Old Believer iconographers.

At the wedding ceremony, each set of parents presents their icon to the couple, blessing the marriage in the process. The groom's parents usually present him with a metal icon of Christ on the Cross. The bride's parents usually give her an icon of the Mother of God. As the Old Believers make no distinctions between the spiritual quality of a metallic or wooden icon, either type may be presented.

After the ceremony, the couple, holding their icons in white handkerchiefs, take them to a room in the home of the groom's parents. There the young couple will live for a year or so, until the first child arrives. Once the couple becomes a family, they usually move into a home of their own, taking their icons with them. As more children are born into the family, additional icons are acquired for the occupied rooms of the home.

The icons received at their wedding remain intrinsically special for the new parents. Icons acquired later may eclipse the original pair in size and grandeur and become more prominent in the icon corner. Nonetheless, the original icons, having received the blessing for the wedded pair, are held in special regard and are displayed in places of honor in the home.

The personal icons of the couple make an important appearance again at the end of life. At the funeral service of either party, kin place the personal icon at the head of the open casket, and, later, pass it to a young kinsman to carry at the head of the procession to the grave site. After completing prayers and circling the grave, the relatives place the lid on the casket and lower it into the grave. Then, at the foot of the grave, they place an Orthodox cross in cement. They afix the personal icon of the deceased to the cross, where it remains until the memorial service on the 40th day after death; at that time it is believed that the soul has departed from the grave. The icon can then be removed and returned to the family. Later, it could become a valued, personal icon at another wedding. [See also the Pomorian tradition, pages 15, 16. R.E.A.]

Traditionally graveside crosses were of wood and were made

during the gathering for the funeral. However, the crosses are now made of square metal pipes. The eight-ended cross remains at the foot of the grave. It is not an icon, as it depicts no holy figure, but it is of considerable importance. The grave cross is oriented toward the east, toward the Second coming of Christ. These Old Believers explain that the dead will simply rise up to stand next to their cross to face the returning Christ.

Additional Icons

Many Old Believers strive to acquire additional icons for their homes and other purposes. A person will often obtain an icon of the saint for whom he or she has been named. Families also bring icons to the church or to the prayer hall and display them on the sanctuary screen, the iconostasis. These icons remain the property of the family, and go with them should they leave.

In a church served by a priest, the iconostasis, covered with icons, separates the holy altar area from the sanctuary and congregation. In a prayer hall served by a lay pastor, the eastern wall of the building serves as the iconostasis, there being no priestly altar area to separate from the sanctuary. [For background information on the acceptance of a priestly hierarchy see page 17. R.E.A.]

Until very recently, the Old Believers of Oregon and Alaska had no priests to sanctify the altar area behind the iconostasis, or to bless the church building itself. Instead, they built prayer halls, where they worshiped under the leadership of a "spiritual leader" (*dukhovnyi nastavnik'*), an elder approved by general consent. This leader received the blessing from the previous leader, a method of approval dating back to a time when an Old Ritualist priest bestowed a blessing on their Old Believer ancestors.

Recently a group of the Old Believer elders, after lengthy deliberation, decided to recognize the Old Ritualist Metropolia located in Romania, and sent two of its members to become ordained as priests. Upon their return, the congregation of each priest built a church (one in Alaska and one in Oregon) complete with an altar behind an iconostasis. Others in the two communities have not recognized this priesthood, and continue to attend prayer halls.

Making Icons

With the increase of population of the Old Believers, additional icons are needed. The contemporary Orthodox church would seem an obvious source of both metallic and painted, i.e., "written," icons at reasonable prices. But only in the last few years have the Old Believers accepted these icons. They are, however, particularly careful to have them blessed by Old Ritualist authorities.

There is a distinct preference, however, for older icons from their own community, or for new ones produced within it. Several Old Believer men have gone to great lengths to study and learn the methods of making icons in an acceptable manner for their communities. Young men who show an artistic talent are encouraged to assume the responsibilities by preparing themselves to "write" icons on wood, or "pour" metallic icons.

It is well understood in the Eastern church that the making of icons is not simply a matter of artistic creation. A person selected for the task assumes a major, spiritual responsibility. The preparation of the board, or the melting and pouring of the metal is done in a posture of prayer. The entire process becomes a sacred act. The icon maker, in the minds of the Old Believers, is ranked equal to a priest or *nastavnik* in spiritual status; his behavior in life must befit a pious man.

In the traditional, patriarchal ethic of the Old Believers, it is a man's duty to make icons. Likewise, it is a woman's duty to clean them. These men and women must be "in union," meaning, ritually clean and living properly. There are additional requirements on the women who clean them.

The woman preferred to clean icons should be a "widow," meaning a woman past child-bearing age who is free of conjugal intimacy. In extreme cases, a pre-puberty, virgin girl could perform icon cleaning, but a widow would have greater respect for her duties. The cleaning of icons occurs just before Christmas and Easter, when the entire house, inside and out, is cleaned. A widowed relative comes to the home and carefully "dusts" the wooden icons with a soft, clean cloth. For the metallic icons, she prepares a soup-like base by boiling down yellow beans, which is cooled slightly. The widow soaks the icon in the base for one and one half hours, then rinses it.

Icons on Display

When the Smithsonian Institution requested through the author that a local maker of metallic icons cast one for the display, the iconographer refused; it was known in advance that this example icon would not be used "properly." Justifying himself, the iconographer quoted from his Scriptural understanding: "Damned is he who does the work of the Lord casually or carelessly" (translation).

Nonetheless, as an ethnographer living among the Old Believers, I had the opportunity to show many elders photographs of the Smithsonian's Kunz copper icon collection. They were interested in the history of their acquisition and eager to see them.

On viewing the photographs, the Old Believers recognized the icons and crosses and quickly distinguished between those acceptable to them and those not. Unacceptable were those that, they insisted, are characteristic of icons used by the *Pomortsy*. That faction of Old Believers, shortly after the Reforms of the seventeenth century, took a doctrinal position that a valid priesthood no longer existed. Pomortsy of this persuasion are also called *Bespopovtsy* or "priestless ones." However, there are many other Old Believers who descriptively, as opposed to doctrinally, refer to themselves as *bespopovtsy,* inasmuch as they had no priests available to them for many decades.

Nonetheless, the Old Believers of Oregon do not accept the tenets of the Pomortsy Old Believers, and therefore, do not recognize what they consider to be Pomortsy icons.

In rejecting the Pomortsy icons (i.e., 25819.026), the Old Believers of Oregon and Alaska point out that, on a Pomortsy icon, the dove above the head of Christ, symbolizing the Holy Spirit, is missing. Also, the figure that should portray God at the top of the icon is portrayed by the "Image Not Made with Hands," an image said to have remained on a cloth with which Christ had wiped his face. According to Oregon Old Believers, the Pomortsy insist that, as no one has seen God or the Holy Spirit, one should not portray them with life-like objects. Thus, the life-like dove symbol of the Holy Spirit is omitted on Pomortsy icons, and the figure of God is replaced by the cloth image. Pomortsy and other Old Believer groups may not agree with these delineations. [For further discussions on distinguishing Pomorian icons see page 18. R.E.A.] Thus, these definitional interpretations illustrate once again how interpretations and understandings vary from group to group and region to region.

Of additional interest to the Oregon Old Believers are the crosses that display the sun and moon on the crossbar. A pagan tribe, they say, had converted to Christianity, but had requested that they be allowed to retain the sun and moon symbols. Inasmuch as the tribe is now Christian, the Old Believers have no objection to these crosses.

Lastly, the icons of St. Nicholas (25819.088) are of special significance to those Old Believers of Oregon and Alaska who have recently accepted the line of priesthood from the Old Believer Metropolia in Romania. This saint, known as the "Protector of the Church," is considered to have been instrumental, through a vision, in establishing in the 1840s the Old Believer Metropolia in the Romanian part of Austro-Hungary.

The Old Believers of Oregon and Alaska are intrigued by the Smithsonian Institution exhibit of icons and crosses, which may represent the work of some of their ancestors. Some Old Believers feel a protective responsibility toward these, or any, icons. They are impressed, however, with the proper care given the icons in the display, and, furthermore, with its coinciding with the 1,000-year anniversary of the Christening of Old Rus'. [See The Grand Prince of Kiev, page 23. R.E.A.]

As preservers of the Old Rite, Old Believers value and respect icons with a special intensity. As described above, icons play an intimate and important role in their religious observances at home and at church. Whenever a solemn or holy occasion arises, icons are fervently desired and required. Their presence imbues any occasion with solemnity, beauty, and grace.

Icons in the Daily Life of Pomorians in the United States

Anton Serge Beliajeff

The Orthodox icon or cross is ever-present on the body (the baptismal cross), in the house (usually in every room), in the church, and often in the car.

For the sake of comparison, the focus of this section will be on the use of icons among the Old Believers in the United States, with special emphasis on the Pomorians. [For discussions of Russian Pomorian communities see pages 17, 31. R.E.A.]

Among the many religious questions discussed in these communities, issues concerning icons and the way to honor them are undoubtedly the most common. This is because icons are everywhere and are constantly turned to during the daily round of activities. At a 1969 conference of Pomorians in Erie, Pennsylvania, more than a fourth of the proceedings dealt with icon questions. The discussion confirmed that photographic or lithographic reproductions are not rightful icons. Correct icons are "either painted on the boards, or metallic, made of brass by casting. The metallic Icons are still made by our Christians and are available for everyone."[1] Regarding metal icons, the conference cited the 1909 Pomorian Council held in Moscow, which stated that "crosses cast of brass, as well as painted on wood in the eight-edged shape, are to be accepted by the Church for purposes of worship."[2] At the 13th Annual Conference of Old Orthodox Parishes held in Detroit, Michigan, in 1968, it was emphasized that icons are not idols, the honor due to the icon goes to the saint depicted, and that electrical lamps do not properly "feed" icons.

Other questions that arose at the Erie conference concerned the required height of candles and oil lamps (*lampada*) in front of icons and whether in a newly built house it is the rooms or only the icons contained in them that are to be blessed.[3]

The focus on icons at Old Believer conferences reflects their importance in daily life. At the start of Christian life, at baptism, one is given a baptismal cross on a cord to wear around the neck. This cross remains with the person until death. It must be four-edged on the outside with a smaller eight-edged cross inscribed within the borders. On the obverse is written the prayer: "Let God arise, let his enemies be scattered...."[4]

The eastern corner of a room is the icon corner. Icons are placed on shelves and are never hung. Upon entering a house one should make three bows at the waist to the icons, always making a sign of the cross each time (right shoulder to left shoulder in the Orthodox manner, using two fingers in the case of the Old Believers). Only after the bows are made does one greet the people present.

An Old Believer home contains many more metal icons than an Orthodox home. Old Believers prominently display embroidered cloths around the icons. In the main room, the icon corner has a large metal cross as well as icons of St. Nicholas and the Theotokos (*Bogoroditsa*).[5]

Family members gather before the icons for regular morning and evening prayers. When they bow to the ground before the icons their foreheads touch a square prayer cloth (*podruchnik*). They keep count of the prayers they have said with a *lestovka* (prayer rope, or rosary) made out of cloth or leather. The various groups of "beads" of the *lestovka* represent the nine choirs of angels, the twelve apostles, the 33 years Christ was on Earth, etc. At the bottom are four triangles of cloth or leather representing the four Evangelists.

Prayers in front of icons precede all events of the day. They take place upon rising, before and after meals, before going to work or school, and before leaving on a trip. A Pomorian leader states that "every prayer must be said before the Icons. On Sundays and Holidays the oil lamps before the Icon must be lit."[6] When marriage ceremonies take place at home, the couple to be married kneels before the icon and candles.[7]

Over the doorway of a chapel or church, there is a metal icon or cross, usually in a frame. Old Believer chapels have proportionately more metal crosses and icons than Orthodox churches. The icons stand on shelves, as in the home. Pomorians often frame or box crosses and icons under glass. The oil lamps in front of icons are constantly refilled and adjusted before and during a religious service. In many cases the families of the community keep some of their family icons in the church building.

The cross at the grave site of an Old Believer is at the feet, not the head, the idea being that the deceased would gaze upon the sign of salvation.[8] In Oregon, a metal icon is sometimes left

Anton S. Beliajeff (deceased), Library of Congress, Washington, D.C., 20540.

15

on the grave cross until the traditional memorial service held on the 40th day, but it may be left on if someone is tending the site.[9] [See also pages 8, 9, 12, 13. R.E.A.]

Crosses and icons are placed at any point considered important by Old Believer communities. For example, a cross, icon, or at least a written prayer appears over thresholds in an Old Believer house. In the north of Russia before the Revolution, Old Believers went to the *bania* (the steambath) with a cross and a belt. They made sure to cross themselves at the door, to prevent the evil spirit, the *baennyi,* of the *bania* from harming people or carrying off children.[10]

Some Old Believers today, as in the past, accept only copper-alloy icons. This is true, for example, of one small group in Oregon.[11]

All Old Believers agree that only properly made icons should receive the veneration and bows. For example, Archpriest Avvakum, a leader of the Old Belief in the seventeenth century, said that one should not bow to icons made in the Latin manner, but only to correctly made icons. He taught that one should even bow to correctly made icons when they happened to be in churches that followed the new rules and practices.[12]

Notes

[1]Minutes of the 14th Annual Conference of the Old Orthodox Parishes held in Erie, Pennsylvania, on 31 August 1969, page 2. One of those who cast metal icons and crosses was Paul Zatkoff of Detroit, Michigan, who used the lost-wax process. Roger Zatkoff, 22 June 1987, personal communication.

[2]Ibid., page 2.

[3]Ibid., page 5.

[4]ANONYMOUS, "O pochitanii i noshenii Sviatogo Kresta Gospodnia," *Tserkov'* (Lidcombe, N.S.W., Australia), number 3, 1980, page 30. The prayer comes from Psalm 68 (67 in the Orthodox Bible), verse 1 (2). L. Dal' reported on a folk belief that the baptismal cross had to be of copper as Moses raised the snake on a copper "cross." L.V. DAL' "Zametka o mednykh grivnakh XII veka," *Drevnosti—Trudy Moskovskogo Arkheologicheskago Obshchestva,* volume IV (1874), page 76.

[5]Examples in the exhibit are 25819.003, 25819.102, and 25819.106. Embroidered cloths are illustrated in Suzi Jones, editor, *Webfoots and Bunchgrassers: Folk Art of the Oregon Country* (Salem, Oregon, 1980), pages 122, 123.

[6]V. SMOLAKOV, *Instruction about the Sacrament of Baptism and the Dogmas of the Greek Old Orthodox Faith* (Erie, Pennsylvania: Greek Old Orthodox Church of the Nativity of Our Lord Jesus Christ, circa 1960).

[7]Icon blessing (*ikonnoe blagoslovenie*) is even mentioned in 1840s Moscow police reports on Old Believers, "Dnevnyia dozornyia zapisi o Moskovskikh raskol'nikakh," *Chteniia v Imperatorskom Obshchestve istorii i drevnostei rossiiskikh,* 1886, book 1, page 176.

[8]ANONYMOUS, "O kreste na mogile umershikh," *Tserkov',* number 20, 1984, page 25.

[9]R.A. MORRIS, 14 August 1987: personal communication.

[10]N.V. TRET'IAKOVA, "K probleme religioznogo sinkretizma v staroobriad-chestve (Na materialakh Pechorskoi etnograficheskoi ekspeditsii 1971–1972 gg.)" *(Problemy Istorii SSSR,* Moscow, 1973), pages 390, 391.

[11]In earlier days, representatives of the official church thought some Old Believers bowed only to metal icons, see V. TETERIATNIKOV "Mednye kresty i ikony v narodnoi zhizni," *(Novyi Zhurnal,* number 129, December 1977), page 167.

[12]L.C. BLINOFF, editor and translator, *Life and Thought in Old Russia* (University Park: Pennsylvania State University Press, 1961), page 143. AUNE JÄÄSKINEN offers a longer discussion of Archpriest Avvakum's position in her *Ikonimaalari uskon ja mystikan tulkki* (Porvoo, Helsinki, Juva: Werner Soderstrom Osakeheytio, 1984), pages 117–125. For priestly Old Believers quoting Avvakum, see ANONYMOUS, "Kakim ikonam ne podobaet poklo-niat'sia," *Tserkov',* number 13, 1983, page 26.

Old Believers and the Manufacturing of Copper Icons

Anton Serge Beliajeff

Considering the ubiquitousness of metal icons in the life of Orthodox believers, and considering the millions of icons that were cast during the past three centuries, it is remarkable that on 31 January 1723 the Holy Governing Synod of the Russian Orthodox church under Peter the Great forbade the casting and selling of holy images from copper alloy, the only exception being baptismal crosses worn around the neck. To justify this prohibition, the authorities claimed that the images were not skillfully executed and poorly portrayed the saints and, therefore, deprived the saints the honor due to them. Those copper-alloy icons that were in use were to be locked in the sacristy; those on sale in the markets were to be confiscated and sent to the main magistracy of each town.[1] In May of the previous year, the Holy Synod had also forbidden churches to have icons of any material that were carved, hewn, or sculpted, or that were painted unskillfully or were not in agreement with Holy Scripture.[2]

There is no indication in the literature that the prohibition was originally directed against the Old Believers. It may, in fact, have reflected the government's need to conserve copper for military and minting purposes. Eventually, the prohibition came to be directed primarily against the Old Believers, who made the most use of copper-alloy icons in their religious observances.

Copper icons and crosses, which had acquired deep roots in Russian religious history, held great importance for the Old Believers, who regarded themselves as the true keepers of the traditional Russian Orthodox faith. The Old Believers, as a group, came into existence during the reign of Tsar Alexis as a result of the decisions of the Moscow Councils of 1666–1667, which "reformed" the established liturgical texts and practices. During the reigns of Tsar Alexis and his successors there were enacted a variety of laws and decrees limiting the social and religious rights of the Old Believers.

For their part, the Old Believer community split into competing groups; the principle division being between those who accepted a hierarchy of priests and bishops and those who

did not. The *bezpopovtsy* rejected hierarchy because they believed that the changes instituted by the established church had broken the Apostolic Succession by heretical practices. The *popovtsy* accepted hierarchy because they believed that some legitimate succession was possible nonetheless.[3]

Nineteenth-century records from Nizhnii Novgorod testify to the central role of copper-alloy icons in the religious practices of both major Old Believer groups. An 1854 estimate of the number of Old Believer metal icons and crosses in Nizhnii Novgorod province speculates that if they were all melted down they would provide enough copper to cast cannon for at least one artillery brigade. An indispensable feature of an Old Believer's house was a copper "eight-edged" crucifix (examples of which are prominently featured in the exhibit) or an icon over a gate. *Popovtsy* always had at least a brass crucifix in the icon corner. Among the Pomorians, a *bezpopovtsy* group, a greater proportion of both icons and crosses were of metal. Some of the smaller *bezpopovtsy* groups, such as the *filippovtsy,* had an even larger proportion of brass icons and sometimes used them exclusively. These icons often were embedded in wooden tablets.[4]

Despite the production of hundreds of thousands of cast icons, the authorities had not altogether abandon the prohibition against them. Police reports on Moscow Old Believers as late as 1846 note that "the casting of copper icons, as is known, is forbidden by law."[5] Though the selling of copper-alloy icons and crosses remained technically illegal, trade in them was conducted openly. The one exception was crosses made by the Wanderers, *stranniki,* a small Old Believer group considered dangerous by the government because of their strident anti-establishment views.[6]

Attempts by the authorities to control the Old Believers included the seizure of both metal and non-metal icons from Old Believer chapels and homes. P.I. Mel'nikov (who, ironically, wrote ethnographical novels about Old Believers under the pen name of Andrei Pecherskii) participated, by his own account, in the closure of chapels and the removal of "tens of thousands of icons."[7] An ukaz of the Holy Synod, dated 30 April 1858, mandated the seizure of icons and books during searches of suspected Old Believer homes and chapels. Private

Anton S. Beliajeff (deceased), Library of Congress, Washington, D.C., 20540.

icons that were deemed sufficiently Orthodox were sent back to the owners, while those from chapels were either destroyed or handed over to parishes of the *edinoverie,* a branch of Old Believers that joined the official Orthodox church and thus were permitted to follow the old ritual.[8] One example of these seizures occurred on 2 January 1854, when the head of the Nizhnii Novgorod province took cast copper icons from a house occupied by an Old Believer monk and nuns.[9] Old Believer icons being sent abroad were also sometimes seized at the borders of the Russian Empire.[10]

Legal prohibitions notwithstanding, the manufacture and trading of copper-alloy icons continued unabated in the eighteenth and nineteenth centuries. While the industrial and commercial history of copper-alloy icons has yet to be written, enough material does exist to give a good idea of their quantity, geographical distribution, and value in the marketplace.

The earliest center of Old Believer copper-alloy icon production was in the north, in the region called Pomor'e by the shores of the White Sea. This region gave its name to one of the branches of the *bezpopovtsy,* the *pomortsy* or Pomorians. Andrei Denisov, one of the founders of the Pomorian Vyg Community, located on the Vyg River, drew up the following rules for its treasurer:

In the copper foundry the treasurer must check that all work, whether copper or silver, is done under his authority. The treasurer must write down how much copper is given to the copper foundry as well as how many leaves [of diptychs and triptychs] and crosses are obtained from it and how many are distributed to the brotherhood.[11]

Only a few Old Believer metal icons carry dates. The earliest dated metal icon from the Vyg Community was made in 1719. This triptych includes, among other saints, SS. Zosima and Savvatii, who were especially venerated in the North as the founders of the Solovetsk monastery. Another dated icon from Vyg, a deësis, carries the date 1731. The metal used at Vyg was brass (*latun'*), and some icons were given a golden sheen by passing them through fire. The earliest ones were not enameled, however, enameling soon became the general practice. Icons at Vyg were cast at two furnaces. Polishing and enameling took place in a separate building. Tradition says that the covers and buckles for books were also cast at Vyg.[12]

Historians know the names of some casters of copper-alloy icons. For example, Vasilii Evstratov from Novgorod is known to have worked with his nephew at Sheltoporozhskii *skit,* a Pomorian hermitage near Vyg. At Vyg itself, Vasilii Petrov and Gorbun cast icons of the Twelve Feasts, as well as small icons with and without enamel.[13]

The guiding rule for icon-painters and casters at Vyg was enunciated in the 1780 *Confession of Faith of the Pomorian Fathers:*

We order that icon masters paint and copper masters cast from ancient models according to church tradition upheld by all, with the royal and theological inscriptions as they are on holy, miracle-working crosses, namely—King of Glory Jesus Christ Son of God, etc.[14]

The trade in metal icons at Vyg was sustained, in part, by Old Believer pilgrims from other areas. The Vyg Community also sent out its own agents to sell copper-alloy icons and other religious goods throughout the Empire. As the traffic in metal icons grew, the role of the Vyg Community shifted from production to distribution.[15] By 1835, some years before the Tsarist authorities suppressed the monastic community, Vyg had organized the casting of metal icons in various parts of the surrounding Povonets *uezd.* That year, Vyg obtained 5,000 rubles from the sale of copper-alloy crosses alone.[16]

Pomorian crosses, such as those produced at Vyg and the surrounding *uezd,* have certain distinguishing characteristics. The Vyg leader, A. Denisov, argued that the Pomorians followed the old Orthodox tradition of casting copper crosses without Pontius Pilate's inscription. This is the major distinction between Pomorian crosses and other Orthodox and Old Believer crosses. Yakov Sergeev, who visited the Vyg Community in 1737, wrote, "Pomorians do not bow to a cross with the inscription 'Jesus of Nazareth, King of the Jews'... but make themselves cast ones with the inscription 'King of Glory', and to those they bow."[17] Pomorian crosses, in place of the initials ИНЦИ corresponding to INRI in Latin, have IC ХС ЦРЬ СВЫ (Jesus Christ King of Glory). At the top of a Pomorian cross, a Vernicle replaces the Sabaoth.[18] The best way to understand this is to refer to a cross (25819.026), where the inscription board contains the letters IC ХС. Above the board are the letters ЦРЬ СВЫ and below it the usual letters СНЪ БЖІИ (Son of God).

Unlike the Pomorians, other Old Believer groups agreed with the position of the official Orthodox church that the proper inscription, or *titlo,* on the cross should be ИНЦИ. For example, the *popovtsy* journal *Tserkov'* points out that the ИНЦИ is based on Scripture and is mentioned in the Catechism. The same article goes on to acknowledge that the Pomorian inscription "Jesus Christ King of Glory" was also in use prior to the changes initiated by Patriarch Nikon in the 1650s. However, it concludes that the veneration of the Cross *per se* is more important than the specific inscription on it.[19]

The Theodosians (*fedoseevtsy*), a *bezpopovtsy* group, originally used ИНЦИ, but gradually adopted the Pomorian inscription, also known as ЦС IX СБ. However, a minority of the Theodosians still retained the original "four-letter dogma" after 1791, a distinction that gave them their name of *titlovshchina.* By the end of the nineteenth century, *titlovshchina* were concentrated primarily in the provinces of Novgorod and St. Petersburg.[20]

The Pomorian Vyg Community was permitted to prosper under Peter the Great because of its contribution to the crucial iron and copper industries. As these industries spread into the Urals during the eighteenth century, Old Believer metallurgical masters from Vyg and elsewhere migrated with it. The *bezpopovtsy,* located primarily in the north, tended to move east along the established trade routes. The *popovtsy,* who were concentrated more in the south, went eastward to the Urals and

Siberia along the Volga and Kama Rivers.[21]

The Old Believers clearly played a dominant role in the eighteenth-century Russian metallurgical industry. Their dominance was particularly strong in the Urals, where they provided much of the labor force and most of the skilled masters. Building on their expertise and group solidarity, they soon established themselves as managers and owners as well. One Old Believer family, the Demidovs, controlled most Urals metallurgy by the early eighteenth century. They maintained close ties with the original Pomorian community at Vyg and supplied it with copper, gold, silver, money, and stores. Extensive Demidov properties were later sold to Savva Yakovlev, a Theodosian. In fact, most of the metallurgical specialists, both in the Urals and in other noted centers such as Olonets, Velikii Ustiug, and Tula, persisted in the Old Belief well into the nineteenth century.[22]

Moscow, as can be expected, also became an important center in the manufacture and trading of metal icons, especially after 1771, when both the *popovtsy* and the *bezpopovtsy* became firmly established in the capital. Rogozhskoe cemetery became the focal point for the *popovtsy* and Preobrazhenskoe cemetery for the Theodosian *bezpopovtsy*. Crosses were cast at the Theodosian cemetery soon after its establishment.[23]

Moscow was important in the manufacture and trade of a whole variety of religious goods. For example, the manufacture of hand-held copper censers with a cross on top, which were used exclusively by Old Believers, was concentrated in Moscow and Tula, the latter city having an ancient metal working tradition.[24]

Some names of Old Believers who cast copper-alloy crosses and icons in Moscow appear in police reports from the 1840s. The same reports indicate a large Old Believer demand for baptismal crosses. The Theodosian Ivan Trofimov was engaged in casting icons with his assistant Emel'ian Afanas'ev. One of Trofimov's colleagues, Vasilii Peterov was exiled to Siberia, where he continued to cast copper-alloy crosses and icons for Siberian Old Believers at a merchant's house in Tiumen'. Ignat Timofeev cast icons in large quantities for the *bezpopovtsy*. His icons and crosses were sold by merchants in places as diverse as St. Petersburg, Saratov, Kazan', and Tiumen'. The cast icons and crosses were sent from Moscow in units of poods. One pood, or 16.3 kilograms, was worth 75–80 rubles.[25]

Minor Old Believer groups also had their own locations for casting eight-pointed crosses and icons. For example, the Wanderers (*stranniki*) appear to have done most of their casting near the village of Borodino in Tver' province.[26] The major spiritual center for this group, the village of Sopelki, near Yaroslavl', also produced small metal icons. The Wanderers refused to venerate icons and crosses made by non-Wanderer hands.[27]

By the middle of the nineteenth century the major areas for casting metal icons and crosses were the provinces of Moscow, Olonets, and Yaroslavl', as well as a number of places in the province of Nizhnii Novgorod, specifically Lyskov, Mu-rashkino, and Mareseevo.[28] Another manufacturing center was Il'inskii Pogost, located in Guslitsy, a region not far from Moscow. The Kalikin collection, in The Hermitage, Leningrad, has a number of eighteenth-century Guslitsy icons that were cast from older, sixteenth century, bone or wood icons with a Vernicle on top. (Small icons of stone, wood, and bone were often used to make forms for metal-icon casting.)[29]

The main center for the buying and selling of copper-alloy icons was the annual Nizhnii Novgorod Fair (*iarmarka*). The major sources for metal icons at the Nizhnii Novgorod Fair were Moscow, Pomor'e, and the provinces of Kostroma, Yaroslavl', and Nizhnii Novgorod. Collectors of antique religious objects came to the fair regularly. There were also year-round dealers in copper-alloy icons, prayer-ropes, and books, one such being Aleksii Vasil'ev Meledin, from Semenov in the area of Nizhnii Novgorod.[30]

At the Nizhnii Novgorod Fair, traders sold their goods (icons, books, and religious items relating to the Old Belief) in the Sunduk Row, the stone arcades, and at the stalls near the Fair Bridge. In 1853 approximately 50 rubles worth of copper-alloy icons and crosses were bought by those with an historical interest and 1,500 rubles worth by Old Believers. The figures for painted icons were much higher. Old Believers paid a premium for painted icons showing their two-fingered sign of the cross and their spelling of the name of Jesus (Iсусъ vs. regular Iисусъ).[31]

The evidence clearly indicates that Moscow was the second most important center for trade in metal icons. Merchants routinely went on to Moscow following the Nizhnii Novgorod Fair.[32] For other areas there is less information. There must have been a large workshop in the Baltic region at the end of the nineteenth century to account for the large number of copper-alloy icons and crosses unique to that area. These icons tend to be larger in size than any found in Russia proper and, according to one researcher, incorporate late nineteenth-century elements.[33]

One category of nineteenth-century copper-alloy icons called *novodely* (new goods) must be mentioned. *Novodely* were made for sale to people interested in antiquities and nostalgia. They fall into two categories: counterfeits made with old molds, and stylized objects made in an "Old Russian" style that would deceive only a naive buyer. Both tended to differ in metal composition and color from the originals and tended to be relatively crude looking. They were often stamped rather than cast.[34]

Old Believer copper-alloy icons are, according to one researcher:

easily recognizable due to their refined precise decoration, detailed preparation of the surface. Old Believer articles never show signs of carelessness, conventionality, and vulgarization, such as one sometimes meets with in copper castings of other schools. Old Believer craftsmen . . . carefully retouched with a cutting tool worn casting molds. Therefore, their pieces always look as if they were made as one of a kind.[35]

Notes

[1]ANONYMOUS, *Polnoe sobranie postanovlenii po vedomstvu pravoslavnogo ispovedaniia* [Complete Collection of Regulations in the Department of the Orthodox Faith], volume 3, number 999, St. Petersburg, 1875, pages 31, 32. For a decision regarding the poor quality of painted icons see volume 3, number 1076, pages 114, 115.

[2]Ibid., volume 2, number 625, page 293. Such icons continued to survive in the churches, especially in the north and Siberia. See also A. SULOTSKII, "Istoricheskie svedeniia ob ikonopisanii v Sibiri," *Chteniia v Imperatorskom obshchestve istorii i drevnostei rossiiskikh (ChOIDR)*, 1864, book 3, Smes', pages 45, 46; N.N. SEREBRENNIKOV, *Permskaia dereviannaia skul'ptura* (Perm', 1967), 97 pages. Much later, in May 1841, the Tomsk Spiritual Consistory forbade, in an order relating to the certification of icons, the selling of cast icons and ordered the removal of such icons by civil authorities. One reason given for the clergy to discourage the use of cast or carved icons was the similarity of such use to Roman Catholic custom. Nevertheless, copper-alloy icons were in widespread use in western Siberia, and especially so among the local Old Believers, whose icons were occasionally confiscated by authorities. N.G. VELIZHANINA, "Novye dokumenty o reglamentatsii ikonopisaniia v Zapadnoi Sibiri," In *Istochniki po istorii russkogo obshchestvennogo soznaniia perioda feodalizma* [Original Sources on the History of Russian Social Cognition in the Feudal Period] (Novosibirsk, 1986), pages 151, 153.

[3]For a history of the early period of the Old Belief see S.A. ZENKOVSKY, *Russkoe staroobriadchestvo.* (München, 1970). The major Old Believer leader, Archpriest Avvakum, was concerned about the matters of icon painting, see AVVAKUM, "Selected Texts from the *Book of Discourses*," *Slavic (and East European) Review*, volume 8, number 23 (December 1929), pages 249–258; N. ANDREYEV, "Nicon and Avvakum on Icon-painting," *Revue des Études Slaves*, volume 38 (1961), pages 37–44; A. Jääskinen, *Ikonimaalari uskon ja mystikan tulkki* (Helsinki, 1984), pages 117–125.

[4]P.I. MEL'NIKOV, "Otchet o sovremennom sostoianii raskola v Nizhegorodskoi gubernii," *Deistviia Nizhegorodskoi Gubernskoi uchenoi arkhivnoi komissii (DNGUAK)*, volume 9, (1910), pages 260, 261, 264, 265.

[5]ANONYMOUS, "Dnevnyia dozornyia zapisi o Moskovskikh raskol'nikakh," *ChOIDR*, 1886, book. 1, page 151. [Daily police reports on activities of Moscow Old Believers.]

[6]ANONYMOUS, *DNGUAK* [Government reports], volume 9 (1910), page 320.

[7]P.I. MEL'NIKOV, "Zapiska o russkom raskole," *O raskol'nikakh pri Imperatorakh Nikolae I i Aleksandre II* (Berlin, 1904), page 81.

[8]ANONYMOUS, "Zhurnaly nizhegorodskogo gubernskogo statisticheskogo komiteta" [Reports from the Nizhnii-Novgorod State committee], *Nizhnegorodskii sbornik*, volume 6 (1877), pages 276–278. Family or private icons were still kept in Old Believer chapels as can be seen in the request of the peasants of the Danilov settlement (Vyg) in 1843 to obtain their personal icons from those seized at the chapel, *ChOIDR*, 1862, book 4, pages 48, 49.

[9]ANONYMOUS, *DNGUAK*, volume 9 (1910), page 162. [Government reports.]

[10]M.I, USPENSKII, V.I. USPENSKII, and A.I. USPENSKII, "Ocherk tserkovnykh drevnostei goroda Rigi," *Trudy 10-go arkheologicheskogo syezda v Rige*, volume 3 (1896), pages 139, 140.

[11]V.G. DRUZHININ, "K istorii krest'ianskogo iskusstva XVIII–XIX vekov v Olonetskoi gubernii (Khudozhestvennoe nasledie Vygoretskoi Pomorskoi obiteli," *Izvestiia Akademii Nauk SSSR (IAN)*, 1926, page 1484. See also the January section of *Staroobriadcheskii tserkovnyi kalendar'* (STK) [Old Believers' church calendar], 1973, page 10. For a full-length study on the Vyg Community see R.O. CRUMMEY, *The Old Believers and the World of Antichrist* (Madison, 1970), 258 pages.

[12]ANONYMOUS, *IAN* (1926), page 1483.

[13]ANONYMOUS, *IAN* (1926), page 1485. The location of the foundry is shown in an eighteenth-century Pomorian plan of the Vyg settlement, see *STK* (1968) [Old Believer church calendar], page 9. The collection of Fedor Antonovich Kalikin (1876-1971), an Old Believer himself and a restorer,

contains a number of Vyg icons, whose dates he established, including an eighteenth-century Mother of God "Passion" icon with a jutting crown, see M.N. PRINTSEVA, "Kollektsiia mednogo lit'ia F.A. Kalikina v sobranii Otdela istorii russkoi kul'tury Ermitazha," *Pamiatniki kul'tury - Novye otkrytiia 1984*, 1986, page 405. On Kalikin, see M.I USPENSKII, and V.I. USPENSKII, "Pamiati F.A. Kalikina," *STK* (1973), pages 79, 80.

[14]ANONYMOUS, *IAN* (1926), page 1486.

[15]ANONYMOUS, *Entsiklopedicheskii slovar'* [Encyclopedic Dictionary], (St. Petersburg, volume 7a, 1892), page 487. In the north, copper-alloy crosses were attached to *chasoven'ki*, wooden posts or crosses, placed beside roads, at crossroads, and at the entrance to villages. In the cemeteries, posts with triangular tops had crosses attached to the top and small icons nailed to the post itself, see S.I. DMITRIEVA, "Mezenskie kresty," *Pamiatniki kul'tury - Novye otkrytiia 1984*, 1986, page 465.

[16]The medium of exchange in thirteenth century Russia was the *drivna*. The word ruble comes from the Russian *rubit'*, which means "to chop." The ruble was equal to $1/2$ of a drivna. A drivna was worth 200 grams of silver, therefore, one ruble was worth 100 grams of silver. In the sixteenth century one ruble equaled $1/3$ of a drivna; in the seventeenth century one ruble equaled 48 grams of silver; in 1698 it was worth 28 grams of silver; and in the eighteenth century one ruble was worth 18 grams of silver.

[17]ANONYMOUS, *IAN* (1926), page 1484. Regarding other images, the Pomorian Ignatii Beglets (meaning runaway or fugitive) taught that copper-alloy panels depicting the Twelve Feasts should not be venerated, thereby forming a separate group within the Pomorians, N.I. KOSTOMAROV, "Istoriia raskola u raskol'nikov," *Vestnik Evropy*, 1871, book 4, page 515.

[18]S.V. MAKSIMOV, *Brodiachaia Rus' Khrista-radi*. In *Sobranie sochinenii* [The Collective Works of S.V. Maksimov], volume 6 (1896), page 170. See, for example, Kunz collection number 25819.026. Pomorian cast icons are mentioned by M. Gor'kii in his *V liudiakh* (Moscow, 1948), page 158. See also the 21 February 1848 entry in *ChOIDR*, 1892, book 2, page 178.

[19]ANONYMOUS, *Tserkov'*, 1912, number 52, page 1256.

[20]P.S. SMIRNOV, *Istoriia russkogo raskola staroobriadchestva* (St. Petersburg, 1895), page 110; Johannes Chrysostomus OSB [Order of St. Benedict], "Weniger bekannte Gruppen under den russischen Altgläubigen," *Kirche im Osten*, band 21/22 (1978/1979), pages 249, 250.

[21]S. ZENKOVSKY, "Staroobriadtsy tekhnokraty gornogo dela Urala," *Zapiski Russkoi akademicheskoi gruppy v SShA*, volume 10 (1976), pages 158, 159.

[22]Ibid., pages 161, 166, 171.

[23]F.V. LIVANOV, *Raskol'niki i ostrozhniki* (St. Petersburg, 1872), volume 4, page 35.

[24]ANONYMOUS, *DNGUAK*, volume 9 (1910), page 266. [Government Report.]

[25]ANONYMOUS, *ChOIDR*, 1885, book 3, page 52; 1886, book 1, pages 125, 126. The published version of the police reports was poorly edited according to a later researcher. In the actual document, Ignat Timofeev appears as Ignat Timokhin, see P.G. RYNDZIUNSKII, "Staroobriadcheskaia organizatsiia v usloviiakh razvitiia promyshlennogo kapitalizma (na primere istorii Moskovskoi obshchiny fedoseevtsev v 40-kh godakh XIX v.)," *Voprosy istorii religii i ateizma*, volume 1 (1950), page 223.

[26]V. SKVORTSOV, *Ocherki tverskogo raskola i sektanstva* (Moscow, 1895), page 50.

[27]MAKSIMOV, op. cit, pages 258, 259. In some provinces *bezpopovtsy* preferred copper-alloy icons exclusively, while *popovtsy* accepted painted and cast icons, see *Obozrenie Permskogo raskola* (St. Petersburg, 1863), pages 175, 176. The same author also says that the *bezpopovtsy* did not accept crosses with images of Sabaoth or the Holy Spirit.

[28]P.I. MEL'NIKOV, *DNGUAK*, volume 9 (1910), page 261; ANONYMOUS, *DNGUAK*, volume 9 (1910), page 325. [Government reports.]

[29]PRINTSEVA, op. cit., pages 405, 406.

[30]ANONYMOUS, *DNGUAK*, volume 9 (1910), page 314. [Government report.]

[31]Ibid., pages 321–323.

[32]Ibid., page 320.

[33]M.M. KRASILIN, "Obsledovanie pamiatnikov izobrazitel'nogo iskusstva na territorii Latviiskoi SSR (drevnerusskaia zhivopis' i ee traditsii v XVIII–XX vv.)," *Khudozhestvennoe nasledie,* volume 10, number 40 (1984), page 215.

[34]Printseva, op. cit., page 406.

[35]*Ibid.,* page 405. An extreme position was taken by Afanasii Ivanov Nokhrin, an Old Believer who taught in the village of Il'ino, near the Lower Urals, and insisted that one should not bow to copper-alloy crucifixes and icons, for they are idols, N.N. POKROVSKII, *Antifeodal'-nyi protest uralo-sibirskikh krest'ian-staroobriadtsev v XVIII v.* (Novosibirsk, 1974), pages 189, 190. For a thorough discussion and additional information on Old Believers and copper-alloy icons, see the following articles by M.N. PRINTSEVA: "Pamiatniki melkoi mednolitoi plastiki v sobranii Gosudarstvennogo muzeia istorii religii i ateizma," *Nauchno-ateisticheskie issledovaniia v muzeiiakh* (Leningrad, 1983), pages 35–49; "K voprosu ob izuchenii staroobriadcheskogo mednogo lit'ia v muzeinykh sobraniiakh," *Nauchno-ateisticheskie issledovaniia v muzeiakh* (Leningrad, 1986), pages 47–68.

Iconographic Form and Content in the Kunz Collection

Basil Lefchick

We may encounter the "minor" devotional crosses and icons of the Kunz collection unaware that they are, in microcosm, embodiments of a vast and profound reservoir of art only recently "discovered" by the West. It is an art form almost exclusively religious in content and function—a Christian art intended to move believers to prayer, meditation, and "change of heart" (*metanoia* in Greek). The primary sources of its content are the Old and New Testaments, and the liturgical texts and the hagiography of the Orthodox Catholic church.

Iconography Defined

"Iconography" is the term used to identify this representational art of Christian content. The term "icon" derives from the Greek word for "image" (*eikon*). Used as a technical term, it designates the sacred liturgical art of the Orthodox church that fused elements from Rome, the Hellenistic world, and from the East "welded together and tempered by the direct influence of the new Christian faith."[1]

"Byzantine Art" is the conventional title identifying this art of the Orthodox church. While conventional, the term "Byzantine" is a modern scholarly invention not used by those it means to identify. From the fourth to the fifteenth centuries the representatives of this tradition would have identified themselves simply as "Romans."

Historical Overview

The main center of Byzantine art was the city of Constantinople, "New Rome," as it was called. Due to its location "at the very eastern extremity of Europe, and on the only direct sea route between Russia and the Black Sea to the north and Greece, Syria, Italy, Egypt, and all the rich and powerful area to the south,"[2] developments within the artistic currents of Constantinople radiated out along the trade routes to shape the work of artists throughout the Byzantine world.

Although icons were executed in mosaic, fresco, and egg tempera and ranged in scale from monumental mosaics to miniature illuminations in manuscripts, sculpture was reduced

Basil Lefchick, Center for the Arts and Religion, Wesley Theological Seminary, 4500 Massachusetts Avenue, Washington, D.C.

to a minor role. Sculpture was deemed unsuitable for the interior decoration of churches as they had to be kept unobstructed for liturgical purposes.

Byzantine Art Theory

The underlying theory of art embraced by Byzantine artists was based on Plotinus who was, as Steven Runciman points out, "obsessed" with light: "Beauty of colour derives from the conquest of the darkness inborn in matter by the pouring-in of light, the unembodied."[3] The Byzantines, so fascinated by the varying effects of light, "equated colour with the intensities of light."[4] For this reason, mosaic was considered the perfect medium through which to express the "Light" of the Gospel. While the mosaic medium and its monumental application were patronized by no less than the emperor himself, the need for "accessibility" led simple believers and sophisticates to seek personal icons for their own domestic devotions. This led to the development of "minor" religious art that mimicked in reduction the monumental art of the church.

Typical Aspects of Byzantine Art
Found in the Kunz Collection

Although I shall not attempt an exhaustive analysis of every item in the collection, it is hoped that a selection of the main "types" of images will provide a sense of the interaction of theology and art unique to this tradition. One should derive a sense of the collective creative mind behind these devotional objects.

ICONOGRAPHIC INSCRIPTIONS.—It will be noted that inscriptions appear in either Greek or Old Church Slavonic letters. This is understandable when it is recalled that Christianity was brought to Russia by Greek missionaries sent from Constantinople. These missionaries brought not only the faith but also a culture and the prerequisites for literacy.

During the second half of the ninth century, two Greek brothers from Thessalonica, St. Cyril and St. Methodius, were sent as missionaries to the Slavs. In order to translate the Bible and service books into Slavonic, they first had to invent a suitable Slavonic alphabet. Based on the Greek alphabet, their "Cyrillic" alphabet opened the world of literature to the

Russians and other Slavs.

Not only literature but the world of art was opened to the Slavs. The Grand Prince of Kiev, Vladimir, was converted to Christianity around 988. He began in earnest the process that would eventually make Orthodoxy the state religion of Russia. Greek artists were summoned to create the mosaics and frescoes to adorn newly built churches. Initially, the Greek artists probably executed their inscriptions in Greek. Later, Greek and parallel Old Church Slavonic inscriptions existed side by side. Eventually, when Russian disciples became master iconographers themselves, with few exceptions their inscriptions were in Old Church Slavonic alone.

Inscriptions identifying images of Christ and the Mother of God retained the Greek. This conservative attitude toward Greek inscriptions for the most important figures does serve to show an historical continuity with the origins of Christianity in Russia.

THE CROSS.—As the historically preeminent symbol of Christianity, the image of the cross was always a devotional priority for believers. This was true for Russians as well as Greeks. The present collection contains eight examples varying in compositional detail and degree of ornamentation. All are traditional eight-pointed designs. The simplest (25819.037) shows the figure of Christ with two attendant angels. The most complex version (25819.006) surrounds the corpus with a framework of miniature panels depicting individual saints. Four of the pannels depict Dominical Feasts: the Meeting in the Temple, the Entrance into Jerusalem, the Resurrection, and the Ascension of Christ. In addition, there are two renderings of the Holy Trinity, one "canonical" and one "noncanonical" in form.

Among the crucifixes exhibited, there appear to be two divergent styles used to render the corpus. The first depicts the corpus in a highly stylized, almost "stick-figure" form (25819.003; 25819.004; 25819.006; 25819.009; 25819.054). In two cases (25819.006 and 25819.009) the corpus is surrounded by multiple figures. None of these multiple figures exhibit the peculiarly skeletal rendering of the corpus. The question arises as to whether this treatment of the corpus is intentional, and if so, what is the rationale behind this rendering?

One possible answer is that the emaciated depiction of the corpus was used to emphasize the aspect of Christ's suffering on the cross. If so, how does interest in Christ's suffering fit into the dominant tradition of de-emphasizing the physical sufferings of Christ on the cross in order to stress His "exaltation" on the "Life-giving" Cross?

Both 25819.032 and 25819.037 show a remarkably "naturalistic" approach to rendering Christ's body. The corporeality of Christ's figure is firmly stated. The figure suggests both weight and bulk; it has none of the "dematerializing" stylization of the previously considered crosses. These two "naturalistic" renderings would be at home in the context of Western religious art.

This last observation raises the issue of the influence of Western religious art on the iconographic tradition. The Western image of the cross emphasizes both the corporeality of Christ's figure and the aspect of physical suffering. That this Western tradition affected Orthodox iconography is very clear from history. In 1551 the great "Council of the Hundred Chapters" was held in Moscow precisely to curb the growing influence of sects and the dissemination of Western forms of piety and religious thought. The reign of Peter the Great (1682–1725) has been described as "an age of ill-advised westernization in Church art, Church music, and theology."[5]

It is beyond the scope of the present commentary to explore this issue fully. The question does recommend itself as an apt research project bearing on the religious and cultural interaction of Orthodox (Eastern) and Latin (Western) piety, religious thought, and artistic expression.

Despite the range of variation of detail, certain features are found consistently in all the crosses discussed above. These common features are the keys to understanding the particular "vision" of the cross inherited by the Russian church from Byzantium.

The basic configuration of the crosses (three horizontal bars) reflects a very ancient tradition considered "the most authentic one in the East as well as the West."[6] The topmost crosspiece corresponds to the phylactery bearing Pilate's inscription: "Jesus the Nazarene, King of the Jews." The lower crosspiece is a foot-support (suppedaneum) to which both feet were nailed separately. The use of four nails in the crucifixion scene is found as far back as the illuminations of the Rabbula Gospels, written at Zagba in eastern Syria in 586 A.D.

The oblique inclination of the suppedaneum upward to Christ's right, and downward to his left, has been given various symbolic readings; a "balance beam" of justice, for example, weighing the repentance of the "good" thief against the obduracy of the unrepentant thief.

In addition to the phylactery inscription, other traditional inscriptions appear. Five of the crosses (25819.003; 25819.004; 25819.006; 25819.009; 25819.026) bear the Johannine text: "And when I am lifted up from the earth, I shall draw all men to myself" (John 12:32). This is one of the "keys" to the heart of the Orthodox church's vision of the cross. This vision is based fundamentally on the gospel of John. For John, Christ's crucifixion is his glorious exaltation. In this moment he destroys the power of sin and death over mankind with his own perfect act of self-sacrifice.

Another telling detail of Russian Orthodox crosses is the posture of the figure of Christ. It is not the posture of a body slumped in defeat but, on the contrary, it is a figure that stands in an open-arm gesture of embrace and self-offering.

Christ's divine nature is affirmed by the Greek letters ωOH inscribed within His halo. Taken from the Greek version of the Old Testament (Septuagint), this inscription quotes Exodus 3:14 in which, in response to Moses' request to know God's name, the Lord identifies Himself as " ωOH ": "I am; that is who I am" (New English Bible). Found exclusively on images of Christ, this inscription expresses Orthodox christological

and Trinitarian doctrine.

In addition to the element of John's theological vision is the Pauline contribution: Jesus, on the cross, "emptied himself" (*ekenosen eauton*) of his divine glory and took upon himself the "condition" or "form" of a servant (Philippians 2:5–7). This notion of "kenosis" became a powerful and distinctive feature of Russian Orthodox spirituality from medieval times.

Another Johannine feature of the typical Russian Orthodox cross is the inseparability of Cross and Resurrection. Several crosses (25819.003; 25819.004; 25819.006; 25819.009; 25819.026) bear the inscription: "Before your cross we bow down, O Master, and your Holy Resurrection we glorify." This is a citation from the liturgical text for the feast of the Exaltation of the Cross (14 September) and the third Sunday of the Great Fast preceding Easter. The preeminent position of the Resurrection in the theological, liturgical, and artistic life of the Russian Orthodox church is attested to by these crosses.

Other details are noteworthy. The depiction, for example, of a stylized Sun and Moon (25819.026) or "Day" and "Night" represents the visible world struck dumb by the death of the "Source of Life." The antiquity of this detail is demonstrated by the Rabbula Gospels (586 A.D.). These two symbols, redolent of the Genesis Creation, express the Pauline emphasis on the "cosmic" dimensions of Christ's death and resurrection.

Victory over Death and Hades (*Sheol* in Hebrew) is symbolized by a cavern at the foot of the cross, below the rocky summit of Golgotha. John Chrysostom[7] (344–407), bishop of Constantinople, mentions the belief that the skull within Golgotha's cavern was that of Adam. As John points out in his Gospel (John 19:17), in Hebrew, "Golgotha" means "the place of the skull."

In spite of its apocryphal origin, this detail reflects a significant New Testament christological theme: "The redemption of the first Adam by the blood of Christ, the New Adam, who made himself man to save the human race."[8]

The Cyrillic initial letters " МЛРБ " at the foot of the cross stand for the words: "the place of the skull became Paradise." This reinforces the image of the triumphant King who transforms the barren execution grounds into Paradise. This additional note of victory is repeated in the Greek inscription: " IC ХС НИКА " — "Jesus Christ Conquers" (25819.003; 25819.004; 25819.006; 25819.009; 25819.032).

A pair of angels hover above the figure of Christ in a number of crosses (25819.003; 25819.004; 25819.006; 25819.009; 25819.026; 25819.037; 25819.054). Their attitude is portrayed in the services of Great and Holy Friday: "Before your precious cross, O Lord, the angelic hosts were stunned while soldiers mocked you…" (Third Hour, 4th Plagal Tone). The detail of the cloaks they hold suggests their role as attendants in service to their Lord now crucified. The heavenly hosts are additionally depicted in the six-winged seraphim (25819.004; 25819.006; 25819.009; 25819.026; 25819.032).

Several crosses (25819.003; 25819.004; 25819.006; 25819.009) are crowned by "noncanonical" images of God the Father. He is depicted as an old man identified by the titles "the ancient of days" or "the Lord Sabaoth." Other crosses (25819.026; 25819.032; 25819.037) depict the image of Christ's face "Not Painted by Hands," also known as the "Holy Napkin" (*Mandylion* in Greek).

THE IMAGE "NOT MADE WITH HANDS".—The image of Christ's face "Not Made with Hands" was believed to be a miraculous imprint of the face of Christ discovered at Edessa, Syria in 544. In the West, this is known as the legend of "Veronica's Veil." Once "discovered," the original was transferred to Constantinople in 547. It then became the palladium of the city.

Despite the shell of legend, the theological core of this image is the affirmation that Christian iconography was to depict revealed Truth "Not Made with Hands." This is the foundation of the Church's "program" for its art.

THE TRINITY ICON.—That the "program" or "Tradition" can be violated is illustrated by the previously mentioned images of the Father. The canonical tradition of iconography strictly forbids the direct depiction of God the Father except through an image of His Son. This prohibition is based on the words of Jesus: "To have seen me is to have seen the Father, so how can you say, 'Let us see the Father?'" (John 14:9).

The "canonical" image of the Father was created by depicting Christ endowed with an awesome expression suggesting the Creator's visage. This is Christ "Pantocrator" ("All Powerful"). Traditionally, this image occupied the central dome of churches to stare down upon the faithful far below as they looked up at an image of the Creator and Judge of the world.

Perhaps the principal factor leading to the break with the canonical tradition was the person of Peter the Great (1682–1725). Peter's forceful imposition of Western culture upon Russia included the introduction of Western religious art that conflicted with the canonical tradition in both style and content.

Historically, these noncanonical images of the Holy Trinity depicted the Father directly for the first time. Several crosses in the Kunz collection depict the noncanonical version (25819.003; 25819.004; 25819.006; 25819.009). An old man represents the Father in the company of Christ the Son and the Spirit in the form of a dove.

In at least one case (25819.006), the noncanonical version appears along with the canonical image of the Trinity in the form of the three angel-visitors to Abraham and Sarah. The canonical version represents the three divine persons symbolically. As Leonid Ouspensky points out: "The almost identical faces of the Angels emphasize the single nature of the three Divine Persons and also show that this icon in no way pretends to represent concretely each person of the Holy Trinity."[9]

The canonical Trinity appears on the crests of several icons in the present collection (25819.088; 25819.091; 25819.099; 25819.101; 25819.102; 25819.139; 25819.141; 25819.269; 25819.271). It is noteworthy that, despite the condemnation of

the noncanonical image of the Trinity by the great Moscow Council of 1667, this entrenched version has endured to this very day.

THE RESURRECTION ICON.—As previously mentioned, the theological complement to the Crucifixion image is that of the Resurrection (25819.262). While illustrations of the Resurrection first utilized the Gospel narrative of the myrrh-bearing women at the tomb (Dura Europus, 232 A.D.), the second earliest form was the "Descent into Hades." This image is found on one of the ciborium columns of St. Mark's in Venice, Italy, dating from the 6th century.

Because the New Testament is silent about the actual moment of Christ's Resurrection, this moment is never depicted in the canonical tradition. The scriptural "locus" for this image was found in I Peter 3:18, 19: "In the body he was put to death, in the spirit he was raised to life, and, in the spirit, he went to preach to the spirits in prison."

The copper icon of the descent into Hades (25819.262) shows Christ trampling underfoot the shattered gates of Hades to set free its captives—all who have died from the time of humanity's protoparents, Adam and Eve. Christ extends his hand to raise Adam from the open tomb as Eve looks on. Usually, space permitting, the figure of Christ is surrounded by the kings of Israel David and Solomon, Moses, John the Baptizer, and the righteous women and men of the Old Testament. They are depicted in the moment of recognizing the triumphant Messiah whom they prophesied and for whom they had waited.

This event, taking place in the "depths" of the earth, expresses the "depth" of Christ's abasement (kenosis) and the cosmic dimensions of His victory over sin and death.

THE ICON OF CHRIST IN GLORY.—While theologically of paramount importance, the images of Cross, Resurrection, and Trinity are numerically in the minority compared to images of the Virgin. Icons of the "Mother of God" ("Theotokos" in Greek) indicate the prominent place of the Virgin in the devotion and religious psychology of the Russian church. To explain the widespread popularity of her image, we must turn to the image at the very core of the Byzantine religious mind—the image of Christ "in Glory" (25819.142; 25819.144; 25819.273).

The most awesome version of the Christ in Glory is that of the Pantocrator. As G.P. Fedotov has noted: "The Pantocrator icon leads us to the very heart of Byzantine piety. It is the worship of the transcendent Almighty God whom sinful man can approach only in awe and terror."[10]

At the point of being overwhelmed by the "Mysterium Tremendum" it is the image of the Theotokos to which believers turned. Orthodox piety saw her as the humanly accessible advocate who could call on her Son's filial love to have mercy rather than to pass judgment.

THE THEOTOKOS AS INTERCESSOR.—The first icon in the collection depicting the Theotokos as Intercessor is the icon entitled the "Protection of the Mother of God" (25819.269).

The icon's details are derived from the life of St. Andrew, "the Fool in Christ" (died 956). His vita[11] recounts the appearance of the Theotokos in the church of Blachernes in Constantinople. The Russian church, celebrating this event annually on October 1st, has always commemorated the "Protection" with special solemnity.

In the account of St. Andrew, the Theotokos appears in the church's center, extending a shining veil of her protection over the faithful gathered within. As Queen of Heaven she is surrounded by a procession of saints. Below these figures stands the central figure of St. Romanos the Melodist. He holds an open scroll containing a Christmas hymn in honor of the Theotokos.

The two key witnesses to the appearance, St. Andrew and St. Epiphanius, stand to the right of St. Romanos. In the top left corner is the figure of Christ in heaven, inclining toward the Virgin in response to her prayer.

A second version of maternal intercession is the icon entitled "Joy of all who Sorrow," in Russian (25819.066; 25819.099; 25819.146; 25819.281). This type of icon typically shows the central image of the Theotokos full-length with outstretched arms. In her right hand she holds a scepter signifying her authority and power as Queen of Heaven. Flanking her are two angels whose obeisance expresses her exalted status above all "heavenly Powers."

Clustered beneath her outstretched arms and prostrate at her feet are supplicants seeking her heavenly aid. If, as noted, the Byzantine image of Christ Glorified stressed the inaccessibility of the Transcendent One, accessibility and warmth were found in the image of the celestial Mother.

G.P. Fedotov's commentary on the Theotokos is relevant here:

> The Russian Mary is not only the Mother of God or Christ but the universal Mother, the Mother of all mankind. In the first place she is of course Mother in the moral sense, a merciful protector, and intercessor for men before the heavenly Justice, the Russian version of redemption. But in another ontological sense she was really believed by the folk to be the Giver of Life to all creatures....The extension and significance of her cult is evidenced by the number of churches consecrated to her name, her feasts celebrated, her icons venerated.[12]

ICONS OF THE MOTHER AND CHILD.— In addition to the specifically intercessory images of the Theotokos, the present collection contains five of the main "types" of images showing the Theotokos and Child. I will begin with the most "formal" type and end with the most "intimate" type. The first depicts the Theotokos as "Queen of Heaven" and the last presents her as the ultimate "Mother."

In the type called *Hodigitria* (a Greek title the derivation of which is uncertain; in the Kunz catalog it is titled *The Smolensk Mother of God*), the Christ Child appears seated, erect, on his mother's left arm (25819.136; 25819.217). He is the Child-Immanuel, rather than a babe: his face reflects wisdom far beyond his tender years. The right hand of the Hodigitria is raised in a gesture of formal presentation, while she conveys a

feeling of majestic detachment and imperial dignity.

The *Kazan Theotokos* (25819.078; 25819.271) style first appeared in 1579 at Kazan, the capital of Tator Khanat. This icon played a significant role as the palladium of the Russian troops who liberated Moscow from the Poles in 1612, and in the War of 1812.

The Kazan style icon is probably the most widespread icon of the Theotokos in Russia. It depicts her inclining her head toward her Child-Immanuel in a gesture of greater intimacy than the Hodigitria. She is characterized more as "Mother" than as "Queen."

The *Theotokos of the Passion* (25819.139; 25819.141), *Strastnaia,* in Russian, first appeared in fourteenth century Serbian frescoes. Two angels bearing the instruments of Christ's Passion hover about mother and child. With both hands, the frightened child clutches his mother's right hand as he stares at the symbols of his coming fate. The inclined head of the Theotokos bespeaks a mournful resignation.

The *Theotokos of the Sign* (25819.220; 25819.245) belongs to the "Orans" ("Praying") type of image as indicated by the figure's uplifted hands in a gesture of prayer. Christ appears on her breast either in a "mandorla" (circular or oval "glory") as in 25819.220, or without the mandorla as in 25819.245. This type of image of the Theotokos is found as early as the fourth century (Roman catacomb of "Cimitero Majore").

The image of the Theotokos with the Child-Immanuel in her bosom is the "sign" announced by Isaiah: "The Lord himself, therefore, will give you a sign. It is this: the maiden is with child and will soon give birth to a son who she will call Immanuel" (Isaiah 7:14).

The *Vladimir Theotokos* (25819.106; 25819.130) is a type deriving its name from the Constantinopolitan painting brought to the Russian city of Vladimir in 1155. It was enshrined in the ancient Russian Chronicles where its every move was recorded. The Vladimir Theotokos was considered the palladium of the Russian people: "Throughout the centuries this icon gives its protection to the Russian people and is venerated as the greatest holy treasure of the nation."[13]

The distinctive feature of the Vladimir icon is the intimate posture of mother and child. This feeling of mutual "loving kindness" (*Umileniye,* in Russian) contrasts sharply with the solemn imperial majesty of the Hodigitria.

The Vladimir Theotokos, as all "loving kindness" types of images of the Theotokos, had the greatest appeal for the Russian soul. Believers, often living through great national crises and personal afflictions, found deep psychological comfort in her image. The Virgin's compassion for her cross-destined son was transformed into motherly compassion for all creatures for whom her child would willingly give his life.

The Russian believer saw in her the source of a joy for all created beings whose creatureliness she shared. It was a joy "derived from the consciousness and belief in the motherly intercession of the 'merciful heart' that cannot bear the suffering to which these created beings are subjected."[14]

THE DEËSIS.—The Deësis icon, while still including the element of the intercession of the Theotokos, is usually set apart to occupy a special place of its own. The title "Deësis" is a Greek term meaning "prayer." It refers specifically to the grouping of the Theotokos to the right of the central figure of Christ in glory, with John the Baptizer to Christ's left (25819.142–25819.144; 25819.273).

Frequently in Russian icons the figure of the Theotokos is accompanied by the inscription: "On your right hand stands the Queen" (Psalm 44:9). This scriptural reference emphasizes the role of the Theotokos as the Heavenly Queen.

St. John is included in the Deësis grouping as the last representative of the Old Testament prophetic witness to the coming Messiah. The open Gospel in Christ's hand proclaims the fulfillment of the prophetic expectation realized in his words and works. The configuration of Christ's right hand is an iconographic convention indicating the act of speaking; in this case, Christ speaks the words contained in the Gospel.

A lower register in three of the Deësis icons (25819.142–25819.144) contains busts of individual saints. In one case (25819.273), the enthroned Christ is surrounded by archangels and saints in the same Deësis posture of prayer.

IMAGES OF SAINTS.—The intercessory role of saints—acknowledged paradigms of Christian life—springs from the directive found in the Epistle of James: "…pray for one another, and this will cure you; the heartfelt prayer of a good man works very powerfully" (James 5:16, 17). The logic of Orthodox piety reasoned that if, as St. James teaches, the prayer of a "good man" works "very powerfully," how much more powerful will that prayer be when that good man has passed through death to stand before God's throne among the "chosen"? For this reason, the Russian believer attached himself or herself to acknowledged heavenly victors over evil to obtain their aid.

SAINT JOHN THE BAPTIZER.—The fact that John is included in the Deësis unit is an indication of his special place in the hierarchy of the saints. Catalogue item 25819.083 depicts John as the winged "Angel in the Flesh," an image expressing his ascetic (angelic) life and his role as "forerunner" of Christ. Some of the iconographic details such as his untrimmed hair and beard, and his camel skin garment, are illustrations of his scriptural descriptions.

In John's left hand he holds a bowl containing the infant Christ identified both by his cross-inscribed halo and the open scroll announcing: "Look, there is the lamb of God…" (John 1:29). The imagery here links the biblical "spotless lamb" of Passover sacrificed to save Israel with Christ, the "Lamb of God" whose sacrificial ministry John announces.

SAINT NICHOLAS.—Among Russians, St. Nicholas the "Wonderworker" has always been one of the most popular saints. His appeal was based on his depiction in the hagiography portraying him as a "kind and loving father ready at any moment to come to the rescue of those who call on him."[15]

According to tradition, St. Nicholas accepted ordination to the episcopacy: "in order that one should live no longer for oneself but for others."[16] This "life for others" was the endearing feature of this beloved figure.

The two traditional versions of the image of St. Nicholas are illustrated in the present collection. In the first (25819.066; 25819.156; 25819.226; 25819.227; 25819.279; 1986.0574.01), the central image of Nicholas is flanked by the Savior with Gospel on one side and the Theotokos holding the bishop's identifying vestment, the "omophorion" (pallium), in her hand. The icon depicts a story told by St. Methodius (Patriarch of Constantinople, 842-846) of a vision of Christ and the Theotokos that Nicholas had before he was elected bishop. In the story, Christ hands Nicholas the Gospel while the Theotokos places the bishop's omophorion on his shoulders.

The second version (25819.088; 25819.102; 25819.140) usually depicts a full-length Nicholas with a sword in his right hand and a church in his left. "The sword, the symbol of his spiritual armament, and the church emphasize here St. Nicholas' significance as an implacable fighter for purity of faith and as protector from heresies of the flock entrusted to him."[17]

SAINT PARASKEVA PIATNITSA.—One of the most popular female saints among all Slavs from antiquity was the Great Martyr St. Paraskeva Piatnitsa (25819.057; 25819.223). To the Greek name "Paraskeva" given her at baptism to honour Friday (the day liturgically dedicated to Christ's Passion) is added its Russian translation: "Piatnitsa" (Friday). The use of this translated name added to the Greek baptismal name serves to link Paraskeva's death to the sufferings of Golgotha.

The collection's icons show Paraskeva holding in her right hand the "weapon of her victory—the cross, symbol of following after the passion of Christ."[18] In her left hand an open scroll announces the "Symbol of Faith" (the Creed). This is a statement of her martyr's faith.

The Russian faithful regarded St. Paraskeva as the patron of women's work and, as Friday was market day, she became the patron of trade.

THE ICON OF SAINT GEORGE.—Saint George ("husband-man" in Greek) was the patron of agriculture, herds, flocks, and shepherds. One of the most popular icons of this saint depicts him as "St. George the Victorious" striking down the legendary dragon who was worshipped with child sacrifice.

St. George appears dressed as a Roman, mounted, military commander. The fact that his triumph is God-given is signified by the hand of Christ extended toward George out of an orb representing heaven. The Greek inscription for Jesus Christ usually makes this identification explicit. In the majority of instances, the spear George wields is surmounted with a cross to reinforce the statement that all victory over evil comes from Christ. The example at hand (25819.254) reduces the conventional composition to its fundamental elements.

THE ICON OF SAINT TIKHON.—Saint Tikhon of Zadonsk (1724-1783) was first a monk and later Bishop of Voronezh. He was known for his spiritual writings as well as his life of prayer and dedication to the poor, and in particular, to those in prison for crimes. It has been pointed out that Dostoevsky was inspired by this saint to create the Tikhon in his work, "The Possessed." The icon (25819.135) depicts the saint in his monastic dress holding a scroll representative of his writings. He was formally canonized in 1860.

COLLECTIVE ICONS.—The term "collective icons" is applied to icons in which multiple figures of saints are grouped together. In our collection, these groupings frequently appear on the outer panels of triptychs (25819.066; 25819.106; 25819.130; 25819.136; 25819.139; 25819.141). Usually, the selection of the individual saints who were to be included was determined by the individual ordering a particular icon. A "Family Icon," for example, is a collective icon depicting the patron saint of each family member.

THE TWELVE MAJOR FEASTS.—There are twelve major feasts in the liturgical calendar of the Orthodox church. These feasts celebrate major events in the life of Christ, His mother, and the life of the early church. They are celebrated on the following days according to the Gregorian calendar, or 13 days later according to the Julian calendar.

The Nativity of the Mother of God (8 September)
The Exaltation (or Raising Up) of the Honorable and Life-Giving Cross (14 September)
The Entrance of the Mother of God into the Temple (21 November)
The Nativity of Christ (25 December)
The Baptism of Christ in the Jordan (6 January)
The Meeting of Our Lord in the Temple (2 February)
The Annunciation of the Mother of God (25 March)
The Entrance of Our Lord into Jerusalem (Palm Sunday)
The Ascension of Our Lord Jesus Christ (40 days after Easter)
Pentecost (50 days after Easter)
The Transfiguration of Our Saviour Jesus Christ (6 August)
The Dormition (Falling Asleep) of the Mother of God (15 August)

With the sole exception of the Feast of Pentecost, the twelve major feasts are portrayed in icon 25819.055. The identity of these feast images would be apparent to one familiar with the Gospel narratives they illustrate (e.g., the Nativity of Christ, the Baptism of Christ, the Annunciation, etc.).

The difficulty of identifying individual figures may be instanced in 25819.055. Two monks named "Anthony" and "Theodosius" flank the image of the Hodigitria Mother of God. In theory these could be Anthony of Egypt (died 356) and Theodosius the Cenobiarch (died 529), both monks. In the context, however, of a Russian icon they are undoubtedly the Russian St. Anthony who founded the most famous monastery in all Russia (the Monastery of the Caves at Kiev, founded in 1051), and St. Theodosius, Anthony's disciple, who is considered the founder of Russian monasticism.

Notes

[1]DAVID TALBOT RICE, *Byzantine Art* (Baltimore, Maryland: Penguin Books, Inc., 1960), page 16.

[2]Ibid, page 34.

[3]STEPHEN RUNCIMAN, *Byzantine Style and Civilization* (Marmondsworth, Middlesex, England: Penguin Books, Ltd., 1981), page 37.

[4]Ibid.

[5]TIMOTHY WARE, *The Orthodox Church* (New York: Penguin Books, Inc., 1980), page 128.

[6]LEONID OUSPENSKY AND VLADIMIR LOSSKY, *The Meaning of Icons* (Basle, Switzerland: Otto Walter, Ltd., 1952), page 183.

[7]JOHN CHRYSOSTOM, "On St. John, Homily 85, 1." *In* J.P. Migne, editor, *Patrologia cursus completus, series Graeca,* volume 59, column 459, Paris, 1862.

[8]OUSPENSKY AND LOSSKY, op. cit., page 205.

[9]Ibid, page 203.

[10]GEORGE P. FEDOTOV, *The Russian Religious Mind* (New York: Harper and Row, Publishers, 1960), page 30.

[11]*Patrologia Graeca,* columns 627–888.

[12]Fedotov, op. cit., page 361.

[13]OUSPENSKY AND LOSSKY op. cit., page 94.

[14]Ibid, page 93.

[15]Ibid, page 124.

[16]Ibid, page 123.

[17]Ibid.

[18]Ibid, page 138.

The Technology and Conservation of the Kunz Collection

Vera Beaver-Bricken Espinola

General Historical Background

Small, cast copper-alloy Christian icons and crosses were known in Kiev by the tenth century. They arrived with Byzantine travellers, soldiers, and prisoners even before the Baptism of Rus' in 988. [For further discussion on the Baptism of Rus' see page 23. R.E.A.]

Among the earlier examples of cast metal icons found in Russia are circular two-sided amulets called *zmeeviki*.[1] These came to the attention of Russian scholars in the last century when they were uncovered by farmers plowing the land. Most *zmeeviki* are alloys of copper, lead, and tin, although a few are reported to be made of gold or silver (Figure 4). One side of the medallion has a Christian symbol, such as the Mother of God, Christ, the archangel Michael, or a saint. The obverse side shows either entwined snakes, a human head with Medusa-like snake hair, or full human figures with snakes wrapped around them. The lettering on the medallions is frequently Greek. Recent archeological studies of sites near Novgorod date these *zmeeviki* to the early twelfth century.[2]

Writing in the *Journal of the Moscow Archeological Society* in 1874, L.V. Dal' stated that rare *zmeeviki* icons were often found among Old Believers.[3] He cited the biblical account of Moses who made a bronze serpent on a pole to explain why serpents often appear on these old copper icons, and he attributed the early popular belief that pectoral crosses should be made of copper to the same biblical source:

Then the Lord told him, "Make a bronze replica of one of these snakes and attach it to the top of a pole; anyone who is bitten shall live if he simply looks at it!" So Moses made the replica, and whenever anyone who had been bitten looked at the bronze snake, he recovered! (Numbers 21:8, 9.) [See also note 4 on page 16. R.E.A.]

"But if you don't even believe me when I tell you about such things as these that happen here among men, how can you possibly believe if I tell you what is going on in heaven? For only I, the Messiah, have come to earth and will return to heaven again. And as Moses in the wilderness lifted up the bronze image of a serpent on a pole, even so I must be lifted up upon a pole, so that anyone who believes in me will have eternal life. For God loved the world so much that he gave his only Son so that anyone who believes in him shall not perish but have eternal life. God did not send his Son into the world to condemn it, but to save it." (John 3:12–17.)

Vera B. Espinola, National Museum of American History, Smithsonian Institution, Washington, D.C. 20560.

Metal crosses and icons excavated from twelfth century Moscow burial mounds (*kurgans*) attest to the rise of Christianity in the Moscow-Klyazma river basin area during that era. Some of these eleventh and twelfth century artifacts, however, retain pagan symbols such as a moon with a cross and a sun god, interpolating them with standard Christian images. This appears to confirm the presence of *dvoyeverie* or "dual belief," a practice that persisted for some time despite the struggle of the fledgling eleventh century Kievan church to suppress it.

These recent archeological excavations yielded about forty-two metal crosses and icons associated with the second half of the twelfth century. Among them are a dozen unique pectoral crosses, all of which are four-ended, with none bearing the figure of Christ.[4] Several have rounded ends, and one in particular is similar in shape to modern Russian baptismal crosses. Similar types of cruciforms were also excavated in Kiev and Novgorod (Figure 5).

Information about the metals is limited, although one cross is described as bronze and several as having designs in niello. Some crosses are said to be enameled, without any mention of type or color. Other cruciforms found in the Moscow region are called "Scandinavian" types, similar to those found in Latvia, Lithuania, Estonia, Norway, Sweden, and Finland.[5]

The Moscow sites also yielded six small twelfth-century bronze icons, three of them straight-edged and three round. The icons include one rare early example of the popular "Mother of Tenderness" or *Umileniye* type that represents the Mother of God and the Christ Child gazing upon one another with loving kindness. The reverse of this rare icon shows a six-ended cross.[6]

Mongol invasions of the thirteenth century disrupted the production of metal icons. During this time, miniature icons and crosses were carved of slate, steatite, wood, and bone.[7] Ancient hoards, buried in moments of danger during the Mongol period (1237–1380), indicate not only the route of the incursions, but also provide scholars with valuable information about materials and technology.

The old tradition of copper casting persisted until the seventeenth century in Novgorod and Pskov where the hordes of Khan Batu failed to penetrate. Some of these Novgorodian icons of the Mongol period and later can be seen in The

FIGURE 4.—Three *zmeeviki* icons showing both sides; top and middle are copper, bottom is silver. (Tolstoy,1888)

FIGURE 5.—Twelfth century type four-ended baptismal cross, left (Tolstoy, 1888); modern Russian baptismal cross, right.

Hermitage collections in Leningrad.[8] One distinctive feature is a "twisted rope" design in a flat border with a small four-ended cross in a rhombus on the crest, similar to the icon of Saint George Slaying the Dragon (25819.254) in the Kunz collection.

The end of the seventeenth century brought cultural and religious change and Western influence to the Russian church and state. Some of these events initiated a popular backlash from religious conservatives who came to be known as "Old Believers." In the century-and-a-half that followed, Old Believers founded enclaves where they nurtured old Russian cultural and religious traditions and also came to dominate the production of copper icons and crosses.

The Old Believers

By 1666, liturgical changes and ensuing doctrinal disputes separated the Russian church into two principal factions: those who adhered to the "old belief" championed by Archpriest Avvakum, and those who accepted the "reforms" that Patriarch Nikon introduced in the established, state-approved Church. In 1695, Old Believers fleeing from Novgorod established a self-sufficient secular-religious community in the basin of the river Vyg in the isolated Olonets region. The Vyg community was situated about 40 kilometers above the northernmost tip of Lake Onega in the general area of today's Baltic-White Sea Canal (Figure 6).

Although persecuted and heavily taxed by the State, the Vyg priestless (bezpopovtsy) Old Believer Pomorsky Community (Vygovskaya Pustyn') survived for 150 years until the 1840s. They were an industrious and economically successful people. Many were outstanding artisans, illuminating manuscripts and painting icons, binding books, carving wood, embroidering textiles in silk and gold, and casting in copper and enameling.

Citing a so-called "decline" in their theologically "correct" appearance, a decree was issued by Czar Peter I on 31 January 1723 forbidding the casting and sale of copper icons and crosses as well as their use in churches. It also called for the confiscation of all copper objects except for crosses worn on the person. Ignoring the bans, the casting of copper-alloy icons and crosses continued in Old Believer communities and became a Vyg specialty.

Pomorsky Castings

The Vyg community began casting copper-alloy religious objects at the turn of the eighteenth century and soon became noted for the excellent quality of their crosses, icons, Gospel covers, and clasps for religious manuscripts. The production volume was large enough so that Vyg artisans cast in two furnaces and polished and enameled the objects in a separate building. On 8 February 1780, the Pomorian church fathers wrote that icons and crosses should be cast from old examples that retained their traditions, and that the crosses should have the abbreviation for: "King of Glory, Jesus Christ, Son of God," ЦРЬ СВЫ IC ХС СНЪ БЖIИ.[9] The Pomorian directive was in response to the appearance of the initials IНЦИ on some crosses, reflecting a growing Western influence in eighteenth century Russia. This inscription was a literal translation of the Latin initials I.N.R.I.: "Jesus of Nazareth, King of the Jews," the title written in Latin, Greek, and Hebrew that Pontius Pilate had affixed to the cross.

Documents from 1835 tell of entire villages in the copper-producing Povonets area that cast copper icons and sold them to the leaders of the Vyg Community, who in turn distributed them throughout Russia.[10]

Folding icons with two, three, and four panels figured prominently in the Pomorsky tradition. According to Druzhinin, the style of the triptych covers denoted the period of manufacture.[11] The earliest covers were smooth. Those of the next period were engraved with a cross, occasionally encircled with an ornamental frame. In the third period, the cross and the circle were cast in relief, and an image of the wall of Jerusalem appeared in the background. In the fourth period, the circle became ornamented and the image of the cross and the wall was enameled. Finally, the entire cover design changed: the cross was placed into an oval border with twisted wires (skan'), more ornamental skan' appeared in the design, and the whole was enameled.

Documents relating to the Vyg Community[12] describe devyatki (niners), which are triptychs portraying nine figures. Larger triptychs, depicting twelve feast days on three panels, usually have a fourth panel illustrating four miraculous icons of the Mother of God. These often have a kokoshnik crest over each panel with yet another icon. An example is 25819.055 in the Kunz collection. The Vyg casters liked to make large and small icons of saints who were popular in the Novgorod area, such as St. Paraskeva Piatnitsa; SS. Flor and Lavr; St. George and the Dragon; and St. Nicholas, the Miracleworker. They also produced the Deësis, images of the Holy Trinity, the Crucifixion, and icons of the Mother of God of the Sign.[13] The Vyg Community also made pectoral and benediction crosses of various dimensions, some with added minature cast icons cast in high relief and added to the crosses.

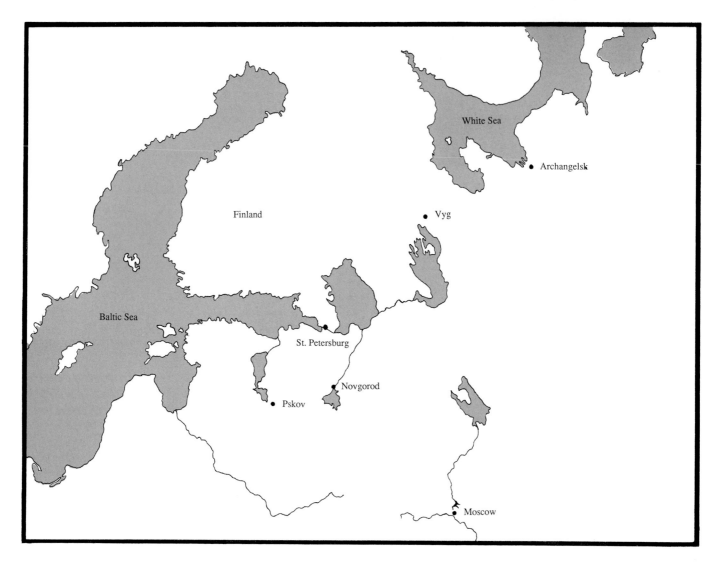

FIGURE 6.—Location of the Old Believer communities of Novgorod and Vyg in Russia. (Courtesy of Valerie Smith)

Many of the copper-alloy icons and crosses were mercury gilded and decorated with polychrome champlevé enamel. Early Pomorsky enamels were transparent, glass-like, and evenly placed, sometimes with added specks of white, black, or primary colors. Later enamels became more opaque and lost their clarity of color.[14]

Pre-nineteenth century Pomorsky casting is technically outstanding. Fine details include the curl of the hair, geometric and floral designs, precise definition of facial features, and miniature architectural scenes. The nineteenth-century revival of popular interest in old Russian culture greatly increased the demand for copper icons and other traditional religious objects, resulting in a decline in quality. Nineteenth-century icons became coarse and heavy. They were also sand cast, but the finished objects were not chased, such as triptych 25819.066 in the Kunz collection. Mid-nineteenth century icons were also manufactured by stamping or electrotyping and are recognized by their thin metal, sometimes just pure copper with an applied patina, such as icon 25819.226.

Physical Examination of the Kunz Collection

MATERIALS.—The Kunz collection of Russian metal icons and crosses, accessioned by the Smithsonian Institution in 1892, consists of 282 objects. About fifty-five are enameled, and a few are gilded. These copper-alloy objects represent a span of 200 years and include manufacturing methods and styles used by the Pomorian and Moscovite *bezpopovtsy*, as well as by the *popovtsy* of Guslitzi and other priestist communities.

Most of the icons and crosses are technically a yellow brass, mainly a copper-zinc alloy with small amounts of tin and lead. Alloys vary according to the date of manufacture. Some seventeenth century brass objects are redder in color, heavier in weight, and softer in physical composition due to a higher lead-zinc : copper ratio. This caused deterioration problems not common to the collection as a whole, such as lead segregation with the formation of surface lead carbonates, as well as dezincification.

ANALYSES.—Seventeen icons and five crucifixes were analyzed by energy-dispersive X-ray fluorescence spectrometry (XRF) at the Scientific Department of the National Gallery of Art in Washington, D.C., by conservation scientists Paul Angiolillo and Lisha A. Glinsman (Table 1). The results were interpreted and correlated by Tom Chase, Head Conservator of the Technical Laboratory of the Freer Gallery of Art and the Arthur M. Sackler Gallery, Smithsonian Institution, Washington, D.C.

GILDING.—A few icons in this collection still have their gilding intact. The gilding on others is patchy and worn from centuries of abrasion, handling, or corrosion of the underlying metal. Some icons retain traces of gilt in the crevices of figure details or under spots of candle wax where it was protected from mechanical wear. Gilding can also be seen under enamel where there are fractures and losses.

The icons appear to have been mercury gilded. Mercury amalgam gilding forms a thin wash that sometimes may only cover the face of the icon and over-run parts of the reverse. The XRF studies done at the National Gallery of Art detected mercury and gold on three eighteenth-century icons (25819.102; 25819.146; 25819.227), which corroborated Druzhinin's statement that icons had been mercury gilded.[15]

Other Russian sources[16] give another formula for gilding copper that did not use the toxic mercury method:

Take two spoons of linseed oil, one not-too-full spoon of *neft* (petroleum) and a pinch of red lead. Put all this together in a copper or clay pot and rub the mixture with a finger on the place of the copper to be gilded. After applying, place it in a pot so it won't bubble. When removing from the heat, put it in the wind and rub with the finger so it will dry. When it is dry, put on the gold and rub it with a rabbit's paw and don't put it in the fire.

ENAMELS.—In the Kunz collection, fifty-one icons (or portions such as wings or panels) and four crucifixes from the eighteenth and nineteenth centuries have champlevé enamels in varying stages of loss. These provided an opportunity for examination and study. In the Kunz collection, the range of colors are light blue, dark blue, white, green, and occasionally, yellow, although not necessarily all on one icon. XRF analyses of enamel on icon 25819.206, circa 1800, showed lead in the blue enamel and lead with some tin in the white enamel. Microscopically, the enamel often has small, open depressions like burst air pockets, which have become receptacles for deposits and debris, contributing to the surface opacity. After cleaning, many enamels may still be considered opaque, but now have a glassy sparkle. The dark blues often acquire a transparency after conservation.

Gilding is sometimes seen under fractured or lifting enamel, such as on crucifix 25819.003, indicating that some were gilded prior to enameling. The metal under broad enameled surfaces is frequently textured or has geometric or linear designs. This type of base may have been designed to provide a more tenacious grip for the fired frit. Icons where only a textured background remains, possibly had been enameled at one time.

An eighteenth-century icon of St. Paraskeva Piatnitsa, 25819.223, has a textured background and appears to have no enamel at all. Under the microscope, however, remains of a transparent, light blue enamel and bits of charcoal can be seen on the lower PR (proper right) corner, as the photomicrograph in Figure 7 illustrates. This example of almost completely lost enamel is one of the reasons why extreme care should be exercised in the examination, conservation, and handling of old Russian metal icons and crosses.

MOLDS.—Little precise information exists about old Russian icon casting techniques, although it is said[17] that early Russian molds for icons and crosses sometimes were made by the imprint of the image in a wet clay or earth mixture, and that special large birch-bark mushrooms called *chaga* were also used for this purpose. Old Russian casting forms were also made of slate (*slanetz*) with the shape and detail of the icon carved into it as a negative image. These finely carved molds made the casting very precise, even without chasing. The casters employed a brown plant powder in the mold to prevent sticking.

Tom Chase, Head Conservator of the Technical Laboratory of the Freer Gallery of Art and the Arthur M. Sackler Gallery, examined ten icons and crosses from the Kunz collection for clues to the method of manufacture and made the following observations:

1. The icons and crosses, representing objects from the seventeenth, eighteenth, and nineteenth centuries, were sand cast, with the exception of 25819.226. Defects common to sand casting can be seen on a number of icons. Grains of sand, sometimes trapped on the surface of the molten metal, were identified as quartz and feldspar in 1983 by Dr. Pete Dunn, Department of Mineral Sciences, National Museum of Natural History, Smithsonian Institution.

2. One icon, 1982.0007.31, has a casting fault where the lower half of the icon was not completed and the metal flowed instead into a bulbous lump on one side. The plaque was sand cast from a metal model. In the model, the multiple seraphim on the crest were individually cast and soldered on, as seen on the reverse where "tabs" overlap the joints. The casting fault was due to a "cold shot" where the metal poured in but didn't flow through completely. According to Vera Espinola's earlier examination, this deformed icon was not discarded when new,

TABLE 1.—Elemental surface composition in weight percent of twenty-two Russian icons. (Cu = copper, Zn = zinc, Sn = tin, Pb = lead, Fe = iron, bdl = below detection limits.)

Display no.	Catalogue no.	Date	Form	Subject	Cu	Zn	Sn	Pb	Fe	Comments
26	25819.141	17 c.	Triptych	The Mother of God of the Passion	77	13	3	6	1	
27	25819.142	17 c.	Triptych	Deësis	76	10	4	9	1	
28	25819.143	17 c.	Triptych	Deësis	78	12	5	4	0.4	
29	25819.144	17 c.	Triptych	Deësis	89	0.8	4	5	0.1	
51	25819.269	17 c.	Plaque	The Protection of the Mother of God	78	12	4	4	0.4	
48	25819.254	17 c.	Plaque	St. George Slaying the Dragon	80	9	5	6	0.4	
07	25819.037	17 c.	3-Arm Cross	Crucifixion of Jesus Christ	86	0.4	5	8	0.1	
08	25819.054	17 c.	3-Arm Cross	Crucifixion of Jesus Christ	74	17	6	1	0.2	
23	25819.136	18 c.	Triptych	The Smolensk Mother of God	70	29	bdl	0.7	0.4	
18	25819.102	18 c.	Triptych	St. Nicholas of Mozhaisk gilded area on obverse*	70	29	0.4	0.6	0.1	on gilded areas gold & mercury detected
45	25819.245	18 c.	Plaque	The Mother of God of the Sign	73	19	4	3	0.5	
38	25819.217	18 c.	Plaque	The Smolensk Mother of God	76	20	2	1	0.2	
42	25819.226	18 c.	Plaque	St. Nicholas the Wonderworker	99	1	bdl	bdl	0.1	
				lead-tin solder	3	0.5	59	36	0.3	
43	25819.227	18 c.	Plaque	St. Nicholas the Wonderworker analyzed gilded area only*						on gilded areas gold & mercury detected
47	25819.251	18 c.	Plaque	The Nativity of the Mother of God	73	14	4	7	0.7	
30	25819.146	18 c.	Triptych	The Mother of God: Joy of All Who Sorrow gilded area	70	28	bdl	1	0.1	on gilded areas gold & mercury detected
03	25819.006	18 c.	3-Arm Cross	Crucifixion of Jesus Christ	67	30	0.2	2	0.2	
04	25819.009	18 c.	3-Arm Cross	Crucifixion of Jesus Christ	79	18	0.3	2	0.2	
05	25819.026	19 c.	3-Arm Cross	Crucifixion of Jesus Christ	70	29	bdl	0.8	0.3	
06	25819.032	18 c.	3-Arm Cross	Crucifixion of Jesus Christ	81	10	5	4	0.4	
12	25819.078	19 c.	Triptych	The Kazan Mother of God	75	22	0.6	1	0.7	
13	25819.083	19 c.	Triptych	St. John the Baptizer	72	13	8	7	0.2	
				tinned area	77	8	12	2	0.2	
				nail hole	74	11	8	5	2	

* These surface coatings cannot be accurately quantitated using XRF due to their varying thicknesses.

These data were obtained by Lisha A. Glinsman and Paul J. Angiolillo at the National Gallery of Art using the KEVEX 0750A energy dispersive x-ray fluorescence spectrometer equipped with a barium chloride secondary target. The weight concentrations were calculated using EXACT software provided by KEVEX Corporation. The detection limit is ~500 ppm. Any amount below 0.1% is considered trace. In none of the icons was the concentration of nickel, silver, or antimony more than a trace except for 25819.217 where silver is ~0.1% and 25819.251 where nickel is ~0.4%.

FIGURE 7.—Photomicrograph of icon 25819.223, revealing remnants of transparent, light blue enamel and bits of charcoal in lower proper right corner. (Vera B. Espinola, photographer)

but appears to have been gilded and was venerated. Candle wax on the icon has turned green from contact with the copper-alloy. When the eyes were worn from use the icon was buried, as seen by the distribution of impacted silicious burial debris.

3. Suspension loops were part of the original castings and a hole was drilled or punched after the object was cast.

4. Some icons have depressions on the reverse that mirror the figure on the front. On an eighteenth century triptych, 25819.099 (Figure 8), it appears that depressions on the back were tooled into the original model both to economize on metal and to prevent tearing due to shrinkage as the metal cooled. Hot tearing is visible on icon 25819.281. This occurs when the section of the casting has thick and thin areas next to each other. The thin areas solidify first then are pulled while hot when the metal shrinks in the thick area. The founders got around this problem by recessing the backs on the icons as described above.

5. Some icons have evidence of sprue marks on the sides. A few icons also show mold marks around the sides from two-piece molds.

6. Three identical-appearing center triptych panels, 25819.142; 25819.143; and 25819.144, are from the seventeenth century. Actually, only icons 25819.142 and 25819.144 are identical and from the same model. Icon 25819.143 is from a different model as can be seen by slightly different details in the book of the bottom PR figure as well as other minor differences.

7. One icon, 25819.226, is not sand cast, but electrotyped, a process developed in the mid-nineteenth century. It is pure copper with an applied patina on the front and a lead-tin solder on the reverse. There is no loop for suspension. This is a good example of how the quality of metal icon production deteriorated when demand increased and rapid manufacturing methods were introduced.

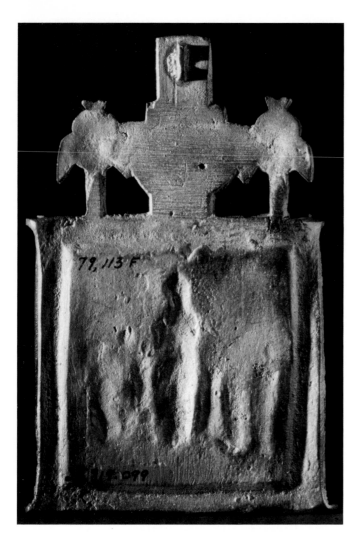

FIGURE 8.—Icon 25819.099 with back depressions. (Vera B. Espinola, photographer)

8. The icon reproduction of St. Nicholas, 1986.0574.01, made in the United States in the 1980s was sand cast from an old model. The face of St. Nicholas has distinct features, but the other four faces are worn smooth, suggesting that only the principal figure on the old icon was reworked before casting.

SHAPES AND SYMBOLS.—The crosses in this collection are mostly eight-ended crucifixes within eight-ended crosses. A few are distinguished by the addition of vertical bars, with standing figures of Mary, the Mother of God, with Mary, the mother of James, together on the proper right of Christ, and St. John and St. John Longinus, the Roman soldier, together on Christ's left. Others have several small metal icons alongside the main cross. Many crucifixes in this collection have prayers cast into the reverse, but some are so worn that they are hardly visible, such as 25819.006. Eighteenth century crucifixes often

have seraphim adorning the top, and still others show God Sabaoth and the letters IHЦИ. The sun and the moon symbols frequently appear on either side of Christ's outstretched arms. The skull of Golgotha is seen below the feet of Christ. The wall of Jerusalem is depicted in crucifixes of the eighteenth century and later in this collection. The feet of Jesus are nailed separately, unlike many Western crucifixes, where one foot is atop the other with a single nail driven through both. Other symbols are the spear and the sponge on a reed, represented as long, thin, vertical objects on either side of Christ's body.

Archeological evidence[18] indicates that the familiar eight-ended Russian cross gradually evolved from four-ended and later, six-ended cruciforms.[19] The eight-ended cross appeared with greater consistency after the fifteenth century, with the slant of the lowest bar varying sometimes from a horizontal position to a left or a right slope. The traditional Russian cross is now identified as eight-ended, with the lowest bar slanting from Christ's right foot down to the left foot.

The shapes of the triptychs and plaques in this collection range from a seventeenth-century curved top (25819.268) to seventeenth and eighteenth-century straight edges (25819.142; 25819.251). There are early eighteenth-century crest shapes (a *bochka*, 25819.057), and eighteenth-century ogee arches (*kokoshnik* shape, 25819.055). Some eighteenth-century icons (25819.279), triptychs (25819.088), and crucifixes (25819.006) have multiple seraphim soldered to the tops. Printseva[20] states that seraphim were added to crucifixes by the priestist Old Believers of Guslitsi.

HINGES AND CRESTS.—Icons in this collection are either triptychs or single panels, with the exception of one four-panel hinged icon. The seventeenth and early eighteenth century triptychs have pintle hinges (25819.141), whereas nineteenth century triptychs have piano hinges (25819.066).

The icon crests and the loops for suspending them on the body also vary. The "Image Not Made with Hands" appears on many icons and crosses throughout the three represented centuries as though a standard. Seventeenth century circular crests depict the "Old Testament Trinity" with an "Image" crest above it, as illustrated by 25819.271. Eighteenth and nineteenth-century icons and crucifixes in this collection, such as 25819.057, show figures of "God Sabaoth." They also portray the "New Testament Trinity," as shown in 25819.055. Modification of crest styles, inscriptions, and symbols mirror Western religious influences in Russia as well as changes among the Old Believers themselves, such as the acceptance of priests.

Loops for suspending the icons were also altered. In the nineteenth century, crests were often omitted entirely and replaced by a simple, pierced metal projection through which a cord is threaded, such as 25819.156. Other such metal projections, as on icon 25819.174, became imperforate and lost their function entirely, remaining only as "deaf ears."

Conservation of the Kunz Collection

The conservation and research of the Kunz collection began with microscopic examinations of each object to evaluate the condition of the metal and enamel and to study details not otherwise visible. This systematic probing became a type of "micro-archeology" as it uncovered evidence of use and aided in the diagnosis and treatment of deterioration problems.

CORROSION PRODUCTS.—The most serious problem encountered was bronze disease, a deterioration of the copper caused by the destructive action of chlorides. The source of chlorides can be water, soil, perspiration, saliva, or any combination thereof. On an eighteenth century crucifix, 25819.004, bronze disease was concentrated on the face of Christ. Bronze disease localized only in one area suggests that it may be use-related. For example, it may be accelerated by the saliva from the religious practice of kissing one spot in particular. Some icons had heavy concentrations of bronze disease only along the raised border at the base, where droplets of saliva could have collected.

The next most serious corrosion product was the formation of lead carbonates. This was caused by the preferential corrosion of lead not completely alloyed with the copper. Segregated lumps of lead near the surface corroded on some seventeenth-century icons, such as 25819.141, with a lead content of about 6%, and 25819.142, with a lead level of about 9%, producing the toxic white powder, lead carbonate. Lead is toxic in very small amounts.[21] Extreme care should be exercised to avoid ingestion of even minute lead particles through touching contaminated gloves or hands to the mouth, or by the religious practice of kissing the affected objects. There is no permanent remedy for this corrosion problem. Objects with a high lead level should be kept in a nonacidic environment with a temperature of about 65°F and 46% relative humidity.

Another deterioration problem is dezincification. Dezincification is the preferential corrosion of zinc usually found in brasses with less than 85% copper. Faults or breaks in the metal combined with oxygen-restricting impacted debris are factors which accelerate a breakdown of the zinc. On triptych 25819.099, areas of dezincification were concentrated under tiny, innocuous-looking flat brown plaques not seen at less than ×40 magnification. When this "lid" was lifted, the deteriorating metal was an unmistakable orange-red copper color, porous, and soft as butter to the probe.

Green copper carbonates, sometimes accompanied by red copper oxides, affected many objects in the collection. Green copper oleates, formed from the reaction of candle wax drippings with copper, were also present on many of the icons and crosses. Russian liturgical candles, often made of beeswax, are traditionally lit near icons as part of a reverential practice. Wax drippings on an icon often indicate this type of ethnographic use. Wax becomes a sealant on the area where it has fallen. This is both good and bad. It is good when the wax protects and preserves the only remaining patch of a worn gilding or adheres some enamel fragments that otherwise might have been lost. It is bad when the wax is in contact with the copper for a very long time and the fatty acid of the wax combines with the copper to produce a lumpy, green copper oleate. The form and substance of this foreign deposit can disrupt the adhesion between the enamel and the metal, causing the enamel to dislodge.

Another frequent deposit on the Kunz collection was a brittle, white polymeric substance. The deposits were fragmentary and adhered to edges, borders, and other places hard to detect. The frequency and distribution patterns suggested that this polymeric material had been used to make molds for icon reproduction. X-ray diffraction and chemical analyses done by the Smithsonian Institution's Conservation Analytical Laboratory[22] confirmed that the material was a synthetic paraffin wax combined with zinc oxide. This was not commercially available before 1946. Remains of this molding compound filled cracks and faults in the metal, sealing the surface and excluding oxygen. An anaerobic environment accelerates the deterioration process of bronze disease and dezincification. Copying old icons and crosses carries the danger of leaving even microscopic remains from a molding compound. This, in turn, can create oxygen-excluding barriers where unnoticed deterioration of the metal may already be in progress. Unfortunately, there is no documentation in the Smithsonian Institution records to indicate when or why the molding was attempted.

Another foreign deposit was a dark brown organic substance, soluble in ethanol, that appeared to be an early (perhaps nineteenth century) attempt at conservation. These opaque resinous deposits seem to have been used for readhering loose enamel. An example is 25819.174, a nineteenth-century icon of the Nativity of the Mother of God, where no enamel was visible before conservation (Figure 9a,b). Complicating the problem on this icon were deposits of the white molding compound over the dark resins with green copper oleates under it all. This indicated that the icon had candles burning nearby and that it was probably covered with a clear resin (possibly shellac) that later turned dark. Some time in the second half of this century, the icon was reproduced using the white synthetic paraffin. In this case, the resin preserved the enamel that might otherwise have been removed by the ravages of time and the copying process. During conservation the deposits were photographed for documentation, removed, and the blue and white enamel stabilized.

Rust deposits were found along the deformed edges of icons and crosses indicating that iron nails had been used to secure them to another object. This can be seen on icon 25819.083.

PRESERVE AND PROTECT.—Metal artifacts should always be handled with gloves. Acids deteriorate metals, and the fatty acids from normal skin contact will contribute to this process.

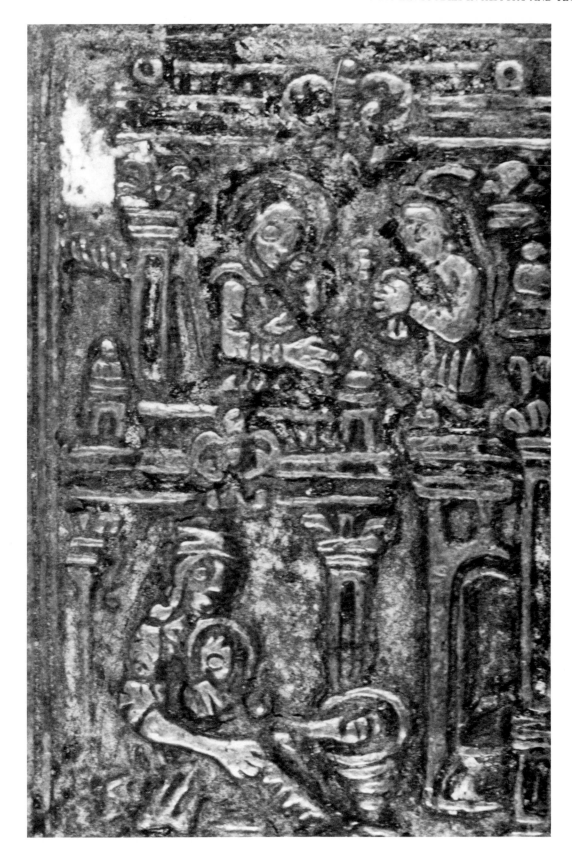

FIGURE 9a.—Icon 25819.174 before conservation. (Vera B. Espinola, photographer)

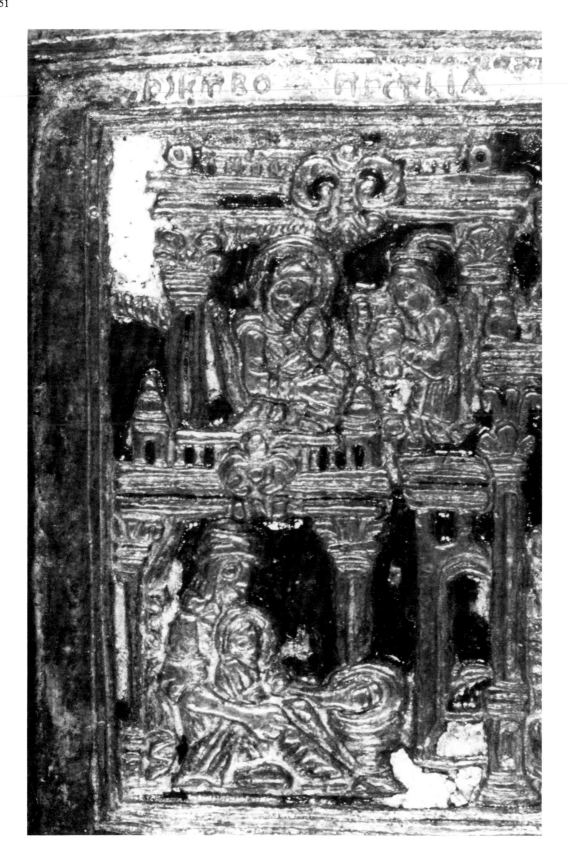

FIGURE 9b.—Icon 25819.174 after conservation. (Vera B. Espinola, photographer)

Old metal icons and crosses in need of conservation should not be cleaned by home methods. Commercial cleaning compounds can scratch the surface, dislodge enamel, remove a naturally acquired patina, leave deposits in crevices, seal in corrosion products, and remove evidence of ethnographic use.

Icons and crosses were made for active religious use, but very old ones are vulnerable to deterioration and require extra care. If in storage, the environment should be stabilized at 68°F. and 50% relative humidity and made nonacidic by excluding acidic papers (such as newspaper), woods (such as oak), and vapors from acidic adhesives (such as may be used in plywood). Polyethylene bags, ventilated to avoid condensation and properly identified, are effective for storing individual icons and crosses. The bags are transparent for viewing and the protected objects can be handled without gloves. To avoid mechanical trauma, pad triptychs and enamels with acid-free paper.

Notes

[1] COUNT I.I. TOLSTOY, "O Russkikh amuletakh, nazivayemikh zmeevikami," *Zapiski Russkago Arkheologicheskago Obshchestva* (St. Petersburg), volume 3 (1888), pages 363–394.

[2] M.V. SEDOVA, "Novgorodskie amuleti-zmeeviki," *Kultura Drevnei Rusi* (Moscow: Nauka, 1966), page 243.

[3] L.V. DAL', "Zametki O mednikh grivnakh XII Veka," *Trudi Moskovskago Archeologicheskago Obshchestva* (Moscow), 2nd edition, volume 4 (1874), page 76.

[4] D.A. BELEN'KAYA, "Kresti i ikonki iz kurganov Podmoskov'ia." In *Sovetskaya Arkheologia* (Moscow: Akademiya Nauk, 1976), number 4, pages 89, 90.

[5] Ibid, page 94.

[6] Ibid, page 96.

[7] LUDMILA DMITRIEVNA LIKHACHEVA AND IZILA IVANOVNA PLESHANOVA, *Drevnerusskoe dekorativno-prikladnoye isskustvo v sobranie Gosudarstvenogo Russkogo Musea* (Leningrad: Isskustvo, 1985), page 214.

[8] M.N. PRINTSEVA, "Kollektsiya Mednogo lit'ia F.A. Kalikina v sobranii Otdela istorii russkoi kul'tury Ermitazha," *Pamiatniki Kul'tury, Novyye Otkritiia, 1984* [Collection of articles published by the Ministry of Culture, RSFSR, Government Museum of the History of Religion and Atheism], (Leningrad: Nauka, 1986), pages 396–407.

[9] VASILY GRIGORIEVICH DRUZHININ, "K Istorii khristyanskovo iskusstva XVIII–XIX vekov v Olonetskoi gubernii," *Izvestiia Akademii Nauk USSR* (Moscow, 1926), page 1486.

[10] Ibid.

[11] Ibid, page 1488.

[12] Ibid, page 1487.

[13] Ibid, page 1483. The Vyg Community also made a triptych with the Deësis in the center panel; Metropolitan Phillip (of Moscow and All Russia, 1569), St. Nicholas the Miracleworker and St. John the Evangelist on the left panel; and the Guardian Angel, St. Zosima (1478), and St. Savatiy, two saints held in high regard by the Pomorians, on the right panel with the date of the casting, 1719, in relief on the exterior. They also made another Deësis triptych dated 1731.

[14] Ibid, page 1488.

[15] Ibid.

[16] A.I. PENTKOVSKY, "New Sources on the History of Gold and Silver Working" (Moscow: The Institute of History of the Academy of Sciences, 1984), page 125.

[17] Personal interviews: Maria Danilovna Malchenko, curator, Division of Russian Cultural History, The Hermitage, Leningrad, 2 October 1987; Larisa Romanovna Pavlinskaya, ethnogrpaher, USSR Academy of Sciences, MAE Ethnographic Institute, Leningrad, October, 1987; and Marina Sergeiivna Shemahanskaya, Head, Metals Conservation Laboratory, All-Union Scientific and Research Institute for Restoration (VNIIR), Moscow, 1980, 1986, and 1987.

[18] BELEN'KAYA, op cit.

[19] Novgorodian cross dated 1280. This is a large, six-ended wooden cross with relics, covered with thin sheets of gilded silver (*bas'ma*). Conservation by Nikita Yurevich Sharkov, the Metals Conservation Laboratory of the All-Union Scientific and Research Institute for Restoration (VNIIR), Moscow, 1979.

[20] M.N. PRINTSEVA, "K Voprosu ob Izuchenii Staroobryadcheskovo Mednovo Litya v Muzeinikh Sobraniyakh," *Nauchno-Ateisticheskiye Issledovaniya v Muzeyakh* (Leningrad: Izdaniye GMIRiA, 1986), page 68.

[21] ALF FISHBEIN, M.D., ET AL, "Lead Poisoning in an Art Conservator," (*Journal of the American Medical Association* volume 247, April 9, 1982), pages 2007–2009. Analyses of lead carbonates by The Smithsonian Institution, Conservation Analytical Laboratory, 1984.

[22] Smithsonian Institution Conservation Analytical Laboratory, report number 4369, 1983.

ILLUSTRATED CATALOG OF THE 1988 NMAH DISPLAY: "CASTINGS OF FAITH: RUSSIAN COPPER ICONS AND CROSSES FROM THE KUNZ COLLECTION"

Richard Eighme Ahlborn, with
Vera Beaver-Bricken Espinola and Basil Lefchick

In addition to the iconographic subject, each icon in the 1988 display in the National Museum of American History is further identified by its display number, from 1 to 57, and by a 3-digit number from .001 to .281. When this 3-digit number is added to the icon collection's inclusive accession number, 25819, each icon has an exclusive Kunz collection number for reference to data in the Museum's files. There are eight exceptions: icons with display numbers 4*, 12*, 23*, 24*, 29*, 37*, and 47* are illustrated for textual reference, but not exhibited; and the last two icons, display numbers 56** and 57**, bear the NMAH catalog numbers 1986.0574.01 and 1982.0007.31, respectively. Each entry in the catalog contains the display number, type of form, Kunz collection number, iconographic subject, fabrication method and materials, dimensions of height (H), width (W), and thickness (T) in centimeters, time period, negative number for photograph, and a brief description. The iconographic subjects are identified by Old Church Slavonic titles, such as "The Mother of God" for the Virgin Mary.

The following tabulation lists all the icons in the catalog by subject matter. Each icon is identified by display number and, in parentheses, the last three digits of the Kunz collection number.

Iconographic subject	Display no. (Kunz no.)
JESUS CHRIST	
The Holy Trinity	41 (.225)
The Nativity of Jesus Christ	17 (.101)
The Baptism of Jesus Christ	32 (.169)
The Image Not Made with Hands	36 (.201)
Crucifixion of Jesus Christ	1 (.003), 2 (.004), 3 (.006), 4* (.009), 5 (.026), 6(.032), 7(.037), 8 (.054)
The Resurrection (The Descent into Hades)	49 (.262)
Deësis	27 (.142), 28 (.143), 29* (.144)
Jesus Christ Enthroned: King of Glory	53 (.273)
MOTHER OF GOD	
The Mother of God of the Burning Bush	45 (.245)
The Nativity of the Mother of God	33 (.174), 47* (.251)
The Annunciation	44 (.230)
The Dormition of the Mother of God	15 (.091)
The Protection of the Mother of God	51 (.269), 57** (.31)
The Mother of God: Joy of All Who Sorow	11 (.066), 16 (.099), 30 (.146), 55 (.281)
The Mother of God of the Passion	24* (.139), 26 (.141)
The Mother of God of the Sign	39 (.220)
The Vladimir Mother of God	19 (.106)
The Tikhvin Mother of God	35 (.198)
The Smolensk Mother of God	23* (.136), 38 (.217)
The Kazan Mother of God	12* (.078), 52 (.271)
SAINTS	
Saint John the Baptizer	13 (.083)
Saint George Slaying the Dragon	48 (.254)
Saints Julitta and Cyricus	20 (.130), 37* (.206), 46 (.249)
Saint Nicholas the Wonderworker	31 (.156), 42 (.226), 43 (.227), 50 (.268), 54 (.279), 56** (.01)
Saint Nicholas of Mozhaisk	14 (.088), 18 (.102)
Saint Nicholas of Zaraisk	25 (.140)

Richard E. Ahlborn, *National Museum of American History, Smithsonian Institution, Washington, D.C., 20560.*
Vera B. Espinola, *National Museum of American History, Smithsonian Institution, Washington, D.C. 20560.*
Basil Lefchick, *Center for the Arts and Religion, Wesley Theological Seminary, 4500 Massachusetts Avenue, Washington, D.C.*

Saint Paraskeva Piatnitsa	10 (.057), 40 (.223)
Saint Antip	21 (.133)
Saint Sergius of Radonezh	34 (.181)
Saint Tikhon	22 (.135)
Church Feasts	9 (.055)

At top appears a frontal view of the torso of God the Father with His arms raised above clouds. Directly below in the top crossbar is a bird, symbol of the Holy Spirit, and at each end, a descending angel with cloth-covered hands. A smaller, three-bar cross, with the corpus, is set into the larger; four Cyrillic letters in the top bar stand for "Jesus of Nazareth, King of Jews." Surrounding this small crucifix are long inscriptions in Old Church Slavonic (see OCS in Glossary), the Greek-letter abbreviation for "Jesus Christ," and traditional elements of the Crucifixion: Jerusalem's walls, sponge-on-reed, spear and a skull set on stones marking the site as Golgotha, "place of the skull." Twisted cords or wire, *skan'*, appear as arches in the slanted, foot-rest crossbar and base, and as three peaks below the dove.

The haloed head of Jesus slumps, but His emaciated body

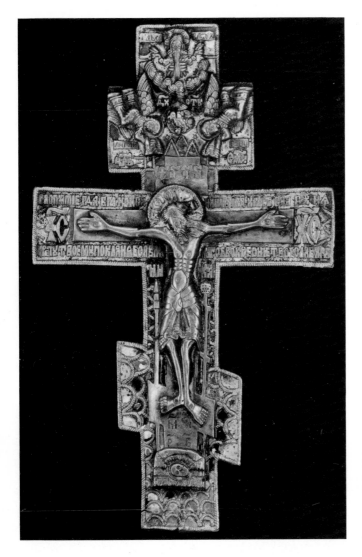

25819.003

1 Three-bar Cross 25819.003

CRUCIFIXION OF JESUS CHRIST

Cast brass with blue and green champlevé enamel over gilding
H: 16.00; W: 9.80; T: 0.21
Nineteenth century
Negative number 87–5664–12

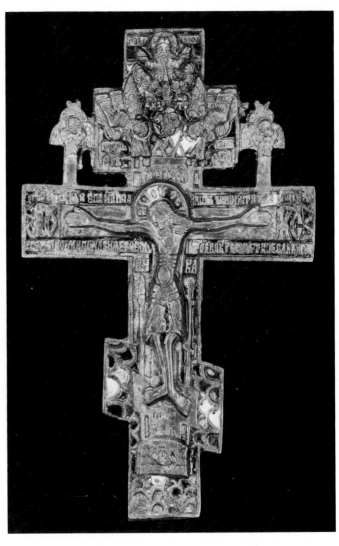

25819.004

suggests no weight or pain. The three-bar cross is also known as an eight-ended cross.

Inscribed prayers in OCS and file marks appear on the back of the casting.

2 Three-bar Cross 25819.004
CRUCIFIXION OF JESUS CHRIST

Cast brass with blue and white champlevé enamel
H: 15.50; W: 9.50; T: 0.25
Eighteenth century
Negative number 87–5664–7

The cross displays the same overall design as 25819.003, but with the addition at each end of the top crossbar of a post surmounted by a seraphim head.

The seraphim head design is traditionally surrounded by three pairs of crossed wings, as noted in the Book of Revelation.

3 Three-bar Cross with Crest and Panels 25819.006
CRUCIFIXION OF JESUS CHRIST

Cast brass
H: 25.50; W: 11.30; T: 0.26
Eighteenth century
Negative number 87–5657–20

Same basic design as 25819.004 but with an additional pierced crest of four seraphim-head posts and seven panels. Each subject is identified by OCS inscriptions; those of the 5 square icon panels are, clockwise from lower PR: "Meeting (of Jesus and Simeon) in the Temple;" "Entry into Jerusalem;" "The Resurrection," also known as "Descent into Hades;" "The Ascension;" and "The Old Testament Trinity." The upper register of each panel hanging from the end of the central crossbar displays paired busts of a saint and an archangel. Below on PR are full-length figures of "The Mother of God" and a second Mary; on PL (proper left) are the saints John the Evangelist and the Roman centurion St. Longinus.

A faint text and file marks appear on the reverse.

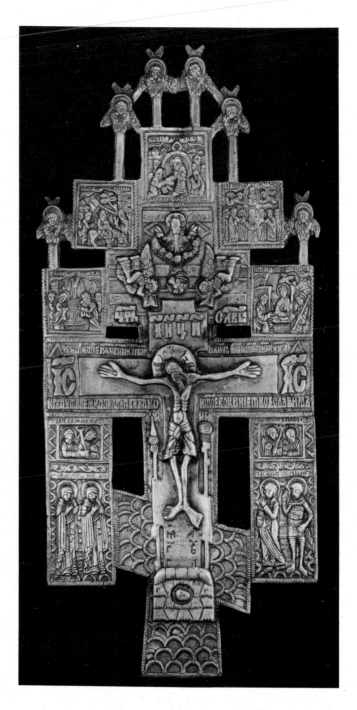

25819.006

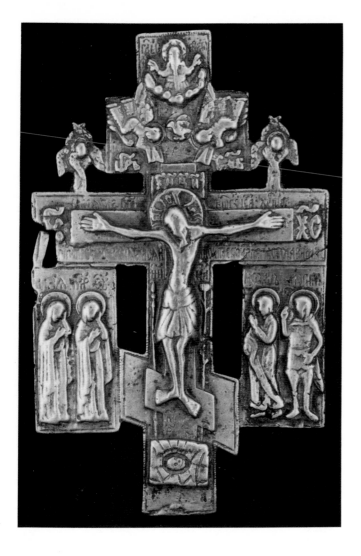

25819.009

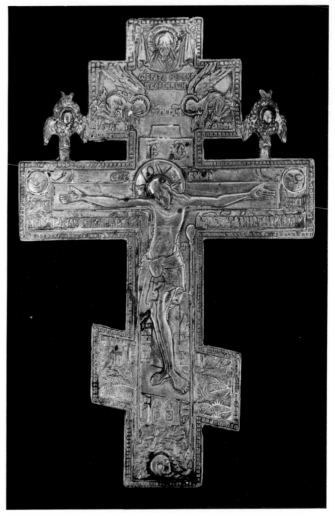

25819.026

4* Three-bar Cross 25819.009
 CRUCIFIXION OF JESUS CHRIST

Cast brass
H: 16.70; W: 10.30; T: 0.27
Eighteenth century
Negative number 87–5657–33

 Same design as 25819.006, but without the paired busts in
the hanging panels. Greek letters in the halo of Jesus stand for
"He who is." A casting fault appears in the PR end of the central
crossbar. Despite this imperfection in casting, microscopic
remains of candle wax and copper oleates suggest that the cross
was used for religious purposes.

 Prayers are engraved on the back.

5 Three-bar Cross 25819.026
 CRUCIFIXION OF JESUS CHRIST

Cast brass
H: 16.80; W: 10.90; T: 0.28
Nineteenth century
Negative number 87–5664–16

 The design is similar to 25819.004, except the uppermost
figure has been replaced by "The Image Not Made with Hands"
(see Glossary). Also, the ends of the center crossbar display the
sun with open eyes (PR) and the moon, with closed; the twisted
wire motif is absent, and the slanted crossbar reveals walls of
Jerusalem (PR) and hillocks with tufts of grass.

 A suspension loop and a plain, raised border appear on the
back.

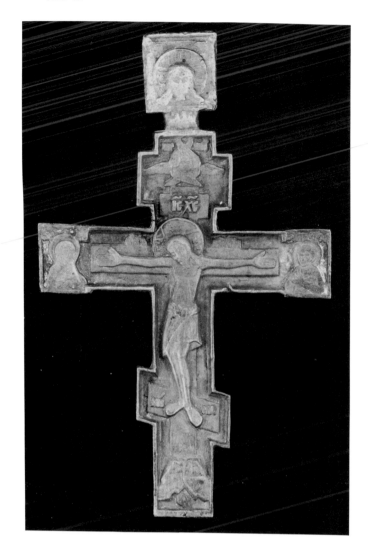

25819.032

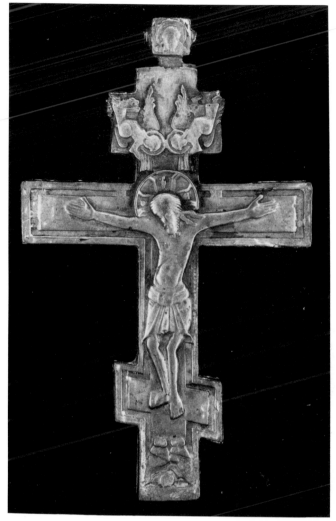

25819.037

6 Three-bar Cross with Finial 25819.032
CRUCIFIXION OF JESUS CHRIST

Cast brass
H: 11.50; W: 7.00; T: 0.22
Eighteenth century
Negative number 87–5657–26

The finial panel displays the "Image" motif. A winged head marked "cherubim" in OCS appears at the top of the cross. There is an inward-facing bust at each end: the Mother of God (PR) and St. John the Evangelist. On the inset cross, Greek letters above and below the corpus stand for "Jesus Christ/Conquers," and Jesus is identified by " ωOH ," Greek letters in the halo, for "He who is." A raised, square molding outlines the front of the cross.

A rear attachment provides for suspension.

7 Three-bar Cross with Finial 25819.037
CRUCIFIXION OF JESUS CHRIST

Cast brass
H: 16.20; W: 9.80; T: 0.43
Eighteenth century
Negative number 87–5657–30

This cross is similar in design and subject to 25819.032. However, the Image finial is smaller, and drilled for suspension. In addition, the top crossbar displays two descending figures (see 25819.003), "angels of the Lord," which replace the cherubim head. The back is recessed.

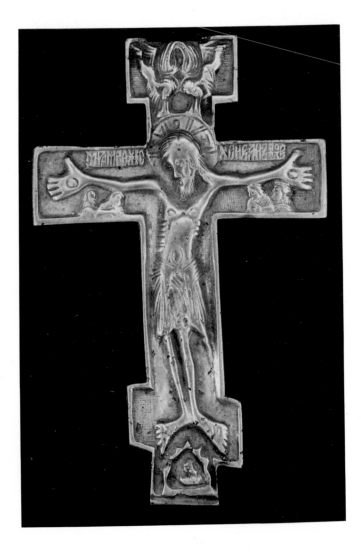

25819.054

8　Three-bar Cross with Finial (?)　　　25819.054
CRUCIFIXION OF JESUS CHRIST

Cast brass, possibly enameled at one time
H: 15.50; W: 10.00; T: 0.36
Seventeenth century
Negative number 87–5664–9

This is similar to the inset cross of 25819.037, except that the element (finial?) is broken off the top and the design of central crossbar is different. It displays an OCS inscription above the outstretched arms of Jesus; below are paired busts representing the subjects shown full-length in the hanging panels of 25819.006. A raised molding surrounds the cross, and the ground is hatched.

The hatching probably helped to secure enamel. Thin hair, enlarged extremities, narrow rib cage and limbs, and linear loincloth imbue the corpus with an intense expression.

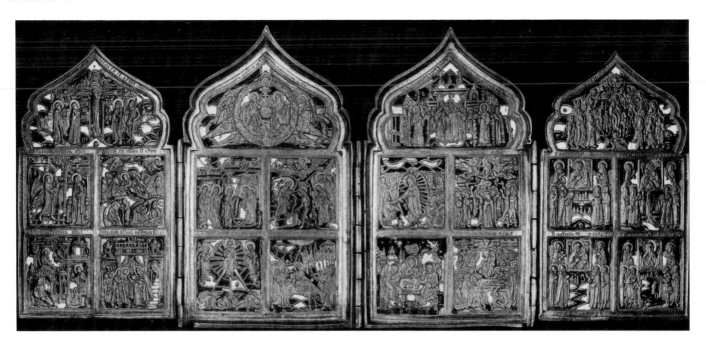

25819.055

9 Icon: Four-leaves with Crests 25819.055
 CHURCH FEASTS

Cast brass, with blue and white enamel
H: 17.00; W: 39.40 (10.50 closed); T: 0.26 (open)
About 1775 to 1825
Negative number 87–5656–17

Each leaf is a rectangle divided into quadrants and surmounted with a raised, ogee-arch, *kokoshnik,* crest. Attached by piano hinges, leaves close over one another from both ends; the two outer backs bear an Orthodox design. Scratched into the back is "40, 10," perhaps the price in rubles and kopecks asked for at the Nizhnii Novgorod fair in 1891. Each of the twenty reserves contains numerous figures, usually in a landscape. Lettering crests from PR and numbering each set of quadrants clockwise from the upper PR, iconographic subjects are as follows:

A The Crucifixion of Jesus Christ
 1. The Annunciation
 2. The Nativity of Jesus Christ

 3. Entrance of the Mother of God into the Temple
 4. The Birth of the Mother of God
B The New Testament (Noncanonical) Trinity
 1. The Meeting in the Temple
 2. The Baptism of Jesus
 3. The Entrance into Jerusalem
 4. The Transfiguration of Jesus
C Exaltation of the Cross with SS. Constantine and Helen
 1. The Resurrection
 2. The Ascension
 3. Dormition of the Mother of God
 4. The Old Testament Trinity
D The Praise of the Mother of God
 1. The Tikhvin Mother of God with SS. Alexander and Cyril
 2. The Vladimir Mother of God with SS. Maxim and Basil
 3. Mother of God of the Sign with SS. Anthony and Leonty
 4. *Smolensk* Mother of God with SS. Anthony and Theodosius

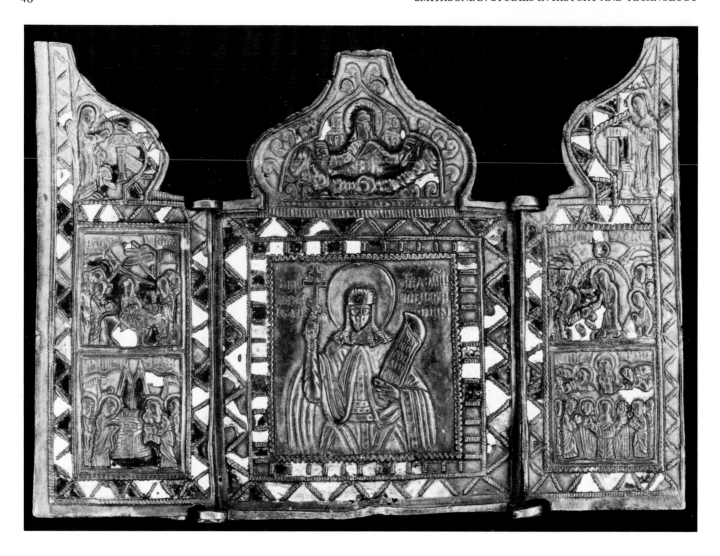

25819.057

10 Icon: Triptych with Crest 25819.057

SAINT PARASKEVA PIATNITSA

Cast brass, gilded under blue and white champlevé enamel
H: 10.50; W: 14.80 (7.50 closed); T: 0.14 (open)
Nineteenth century
Negative number 87–5656–9

The central, modified, ogee-arch crest presents God the
Father (see 25819.003) surrounded by clouds; each lateral
half-crest contains a full-length figure: archangel Gabriel (PR)
and the Mother of God, forming "The Annunciation" subject.
The central subject is represented by a ³/₄-length, frontal figure
of a haloed and robed woman; her PL hand holds a scroll, her
PR raises a three-bar cross. Each wing displays two scenes, one
over one: on PR, "Entrance into Jerusalem" above "Meeting in
the Temple" and, on PL, "Descent into Hades" above "The
Ascension" (see 25819.006 and 25819.055). Each subject is
identified by an OCS inscription. Border reserves of champlevé
enamel are defined with a twisted-wire design. The half-width
wings pivot on pintle hinges, with a flange on the PR closing
over the PL when the wings are folded.

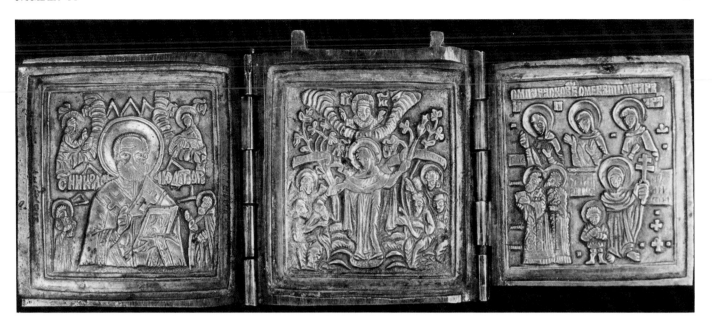

25819.066

11 Icon: Triptych 25819.066
PR LEAF: SAINT NICHOLAS THE WONDERWORKER
CENTER: THE INTERCESSION (THE MOTHER OF GOD: THE
 JOY OF ALL WHO SORROW [*Radost*])
PL LEAF: SAINTS JULITTA AND CYRICUS AND FIVE SAINTS
 (THE SEVEN SAINTS)

Cast brass
H: 6.10; W: 16.30 (6.00 closed); T: 0.54
Nineteenth century
Negative number 87–5650–20

Two posts on central leaf are not drilled for suspension. "The Intercession" is depicted by a haloed, robed woman (Mother of God), who stands with her arms extended outward, over figures kneeling at her side; above appear clouds with OCS inscriptions and God the Father; plants fill the background. On PR leaf, St. Nicholas holds the Gospel and gives a blessing. His bearded head is flanked by half-length figures of Jesus Christ (PR) and the Mother of God. Below stand two male saints; all but the latter are identified by OCS inscriptions. When closed, the back of the PR leaf becomes the front of the icon, displaying a three-bar cross, spear, sponge, and inscription. The leaves pivot on piano hinges. On PL leaf, Julitta and her son, Cyricus, appear in lower PL corner; a bishop and deacon or monk stand beside them. Above appear three half-length figures: St. Paraskeva (PR), Eudokia, and Barbara. OCS inscriptions identify all seven saints.

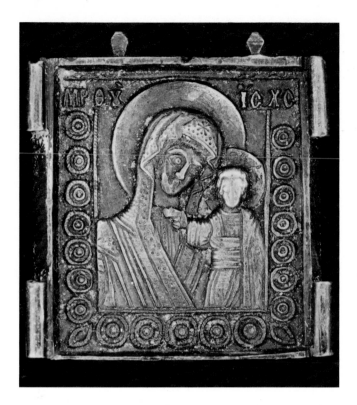

25819.078

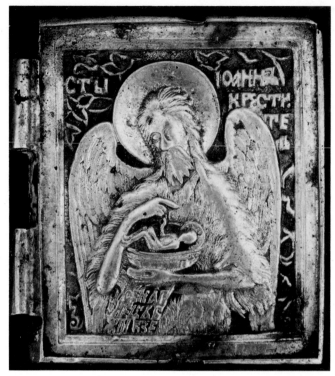

25819.083

12* Icon: Triptych (central leaf only) 25819.078
 THE KAZAN MOTHER OF GOD

Cast brass
H: 4.50; W: 4.50; T: 0.32
Early nineteenth century
Negative number 87–5659–22

At the top, two pierced knops provide for suspension; upper and lower cylinders at each side indicate that the missing leaves hung on piano hinges. There is a wide border pattern of dot-in-concentric-rings. In this advocation of the Mother of God, she is portrayed as a frontal bust with covered head. The head covering is marked with a six-point star, and the head is turned slightly to PL where a frontal, 3/4-length figure of a standing child, the Infant Jesus, extends His PR hand in blessing. Both figures display large haloes and are identified by Greek letters.

13 Icon: Triptych (PL leaf only) 25819.083
 SAINT JOHN THE BAPTIZER

Cast brass and tin plated
H: 6.80 W: 6.30; T: 0.40
Nineteenth century
Negative number 87–5653–5

The recessed-border frame reveals two cylinders of a piano hinge on PR. Leaves fill the ground behind the central figure. The saint is portrayed as a frontal, half-length, elderly man with wings, wearing a long-haired garment. His PL hand holds a bowl containing an infant with flexed legs and raised PR hand; the saint's PR hand points toward the Infant Jesus. At the top are OCS inscriptions.

This piece underwent XRF (see Glossary) analysis in 1985. The leaf could be from an icon portraying "The Deësis" (see Glossary, chapter by Lefchick on iconography, and 25819.142). The top and bottom edges are indented with rust spots, probably from nails that once held this icon fragment in place.

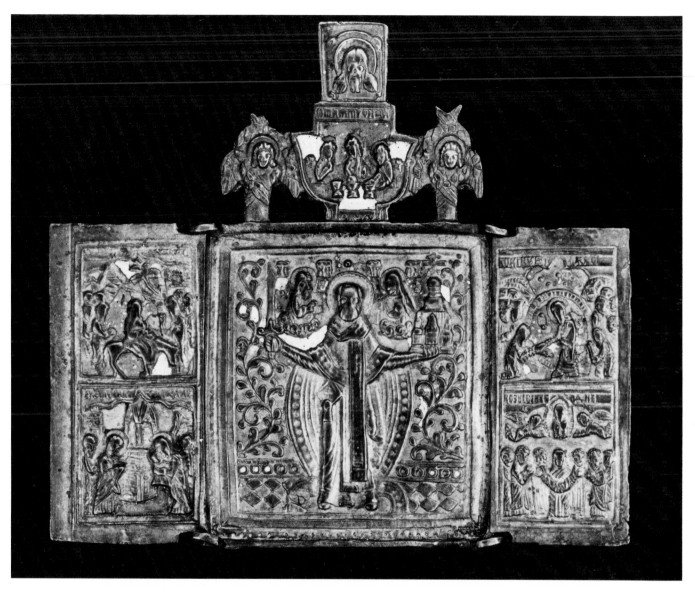

25819.088

14 Icon: Triptych with Crest and Finial 25819.088
SAINT NICHOLAS OF MOZHAISK

Cast brass with gilding under blue and white champlevé enamel
H: 10.30; W: 18.00 (6.20 closed); T: 0.17
Eighteenth century
Negative number 87–5650–24

Image final (see 25819.032) crowns a crest composed of a tulip-shape reserve with three seated figures, The Old Testa-ment Trinity (see 25819.055, C4), with an OCS inscription above and a winged seraphim head at each side. The central leaf shows the saint as a frontal figure standing in priestly robes with arms extended; the PL hand supports a model of a church, his PR raises a sword. A diamond pattern represents the floor, while a band of circles and tendrils fills the space behind. A bust appears at each side of the saint's head: Jesus Christ (PR) and the Mother of God (PL). The half-width wings are attached by pintles and each displays two scenes, vertically, with the same arrangement of subjects as 25819.057.

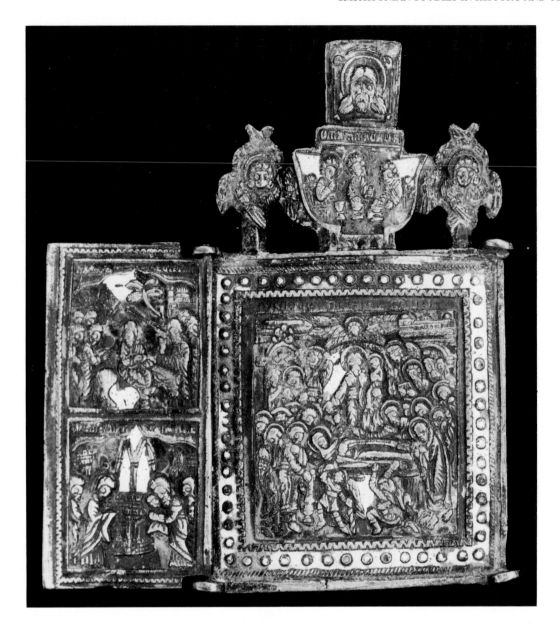

25819.091

15 Icon: Triptych with Crest
 (PL wing missing)
 THE DORMITION OF THE MOTHER OF GOD

Cast brass with blue and white enamel
H: 9.80; W: 8.50 (5.50 closed); T: 0.21
Eighteenth century
Negative number 87–5651–16

25819.091

The design of the crest with Image finial resembles 25819.088. The central leaf displays several grieving apostles and angels with Jesus Christ standing behind the central prone figure of the "sleeping" Mother of God, and holding a figure symbolizing her soul. The scene is framed by a recessed border of dots and zig-zags. Held by pintles, the surviving PR wing repeats the design of 25819.088.

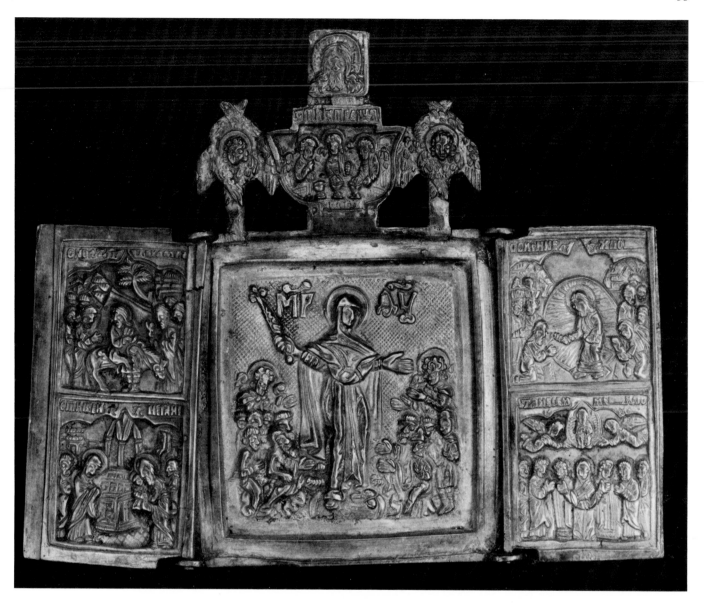

25819.099

16 Icon: Triptych with Crest and Finial 25819.099
THE MOTHER OF GOD: JOY OF ALL WHO SORROW

Cast brass
H: 10.00; W: 12.40 (6.20 closed); T: 0.20
Eighteenth century
Negative number 87–5656–1

Finial, crest, and both wings are similar in construction, design, and subjects to 25819.088, but finial is slightly raised.

The central leaf repeats the subject of the advocation of the Mother of God (see 25819.066), but reverses her figure, and removes the figure of God the Father, the inscription, and the plants, replacing them with Cyrillic letters and a hatched ground. The back leaf shows depressions behind the central figures and frame, and a suspension loop.

Microscopic examination identified fire-rounded grains of quartz, probably from the original sand casting, and white molding material, probably from a later impression (see "Technology and Conservation...", "Molds" by Vera B. Espinola).

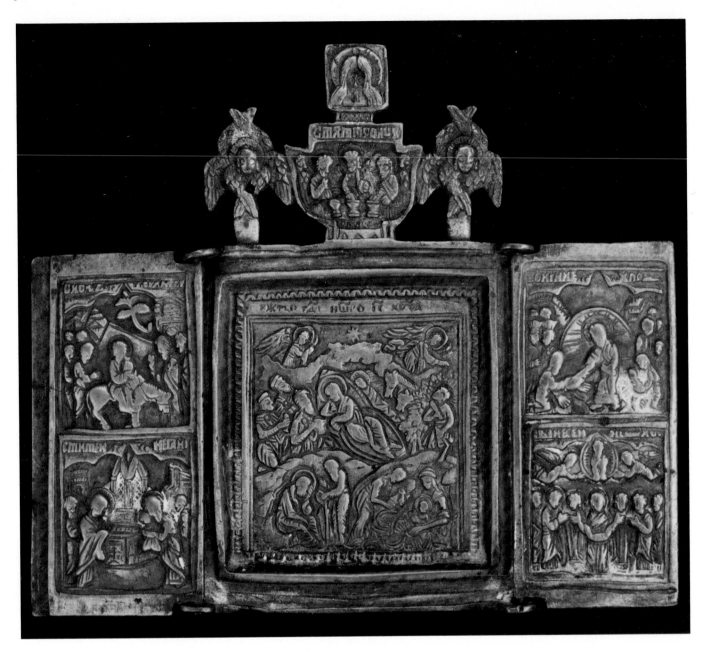

25819.101

17 Icon: Triptych with Crest and Finial 25819.101
 THE NATIVITY OF JESUS CHRIST

Cast brass
H: 10.40; W: 12.20 (6.50 closed); T: 0.20
Eighteenth century
Negative number 87–5650–27

 The finial, crest, and both wings are similar in construction,

design, and subjects to 25819.088. At the top of the central leaf
appear an OCS inscription and star; in the center, the Mother of
God reclines with the swaddled infant Jesus at her PL shoulder.
To the PL are an angel, shepherd, ox, and ass; to PR are another
angel and the three Kings. Two groups appear at the bottom: St.
Joseph, seated, and the Tempter (PR); the two women on the
PL are midwives attending the newborn Jesus. The back reveals
file marks, a depression, and a suspension loop.

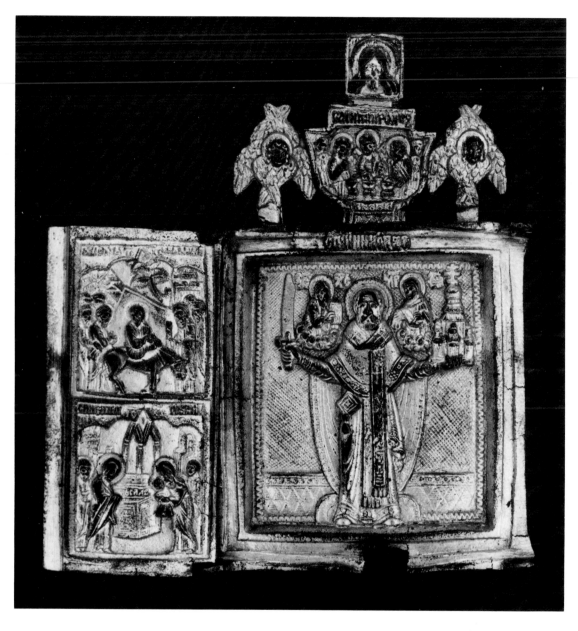

25819.102

18 Icon: Triptych with Crest and Finial
SAINT NICHOLAS OF MOZHAISK

Cast brass with gilding
H: 10.90; W: 10.00 (6.70 closed); T: 0.24
Eighteenth century
Negative number 887–5661–35

The icon reveals the same construction and subjects as

25819.102

25819.088, but PL wing is missing. The background of the central leaf is hatched and surrounded by a zig-zag border.

This icon underwent XRF analysis in 1985, which revealed gilding by mercury-amalgam method. The design of the figure of St. Nicholas resembles that in the popular painted icon in Mozhaisk.

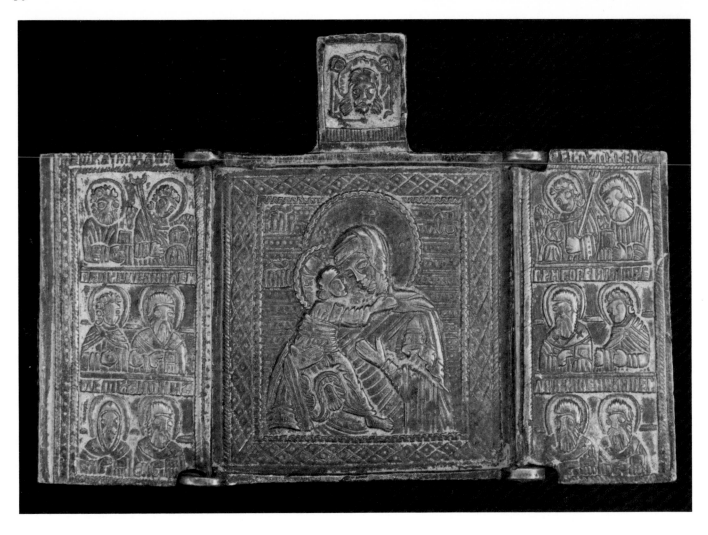

25819.106

19 Icon: Triptych with Finial 25819.106
THE VLADIMIR MOTHER OF GOD

Cast brass
H: 6.40; W: 9.30 (4.80 closed); T: 0.20
Nineteenth century
Negative number 87–5651–9

An Image finial surmounts a square central leaf with a dot-in-diamond border. The half-length figure of the Mother turns to PR and raises her PL hand. She holds the embracing infant Jesus in her PR arm; his foot may be seen. Above appear three pairs of Greek letters; the ground is banded. Attached by pintles, each wing displays three registers, each with a pair of saints identified by OCS inscriptions. From top to bottom, PR wing contains Peter and archangel Michael, George and Basil, and Peter of Moscow and John Chrysostom; PL wing shows Paul and archangel Gabriel, Gregory and Dimitri, and an unidentified bishop and Blaise. A projection on the back of the finial was not pierced for suspension.

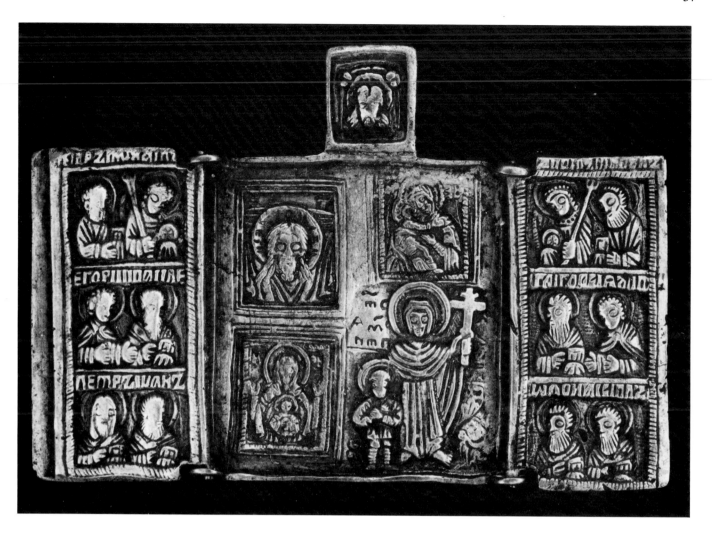

25819.130

20 Icon: Triptych with Finial 25819.130
SAINTS JULITTA AND CYRICUS AND THREE ICONS

Cast brass
H: 6.80; W: 10.10 (4.80 closed); T: 0.17
Eighteenth century
Negative number 87–5651–5

The finial and both wings represent the same subjects as 25819.106. The quadrants of the central leaf represent, clockwise from lower PL: SS. Julitta and Cyricus (see 25819.066, PL leaf), and icons of "The Mother of God of the Sign," "The Image Not Made with Hands," and "The Vladimir Mother of God."

The back reveals deep scratches from an earlier, inept cleaning; a modern, painted inscription, "21163/ Aleutian Is/ J G Swan," refers to an earlier Smithsonian numbering, its attributed origin, and the collector. The suspension loop once retained a fragment of twisted cord.

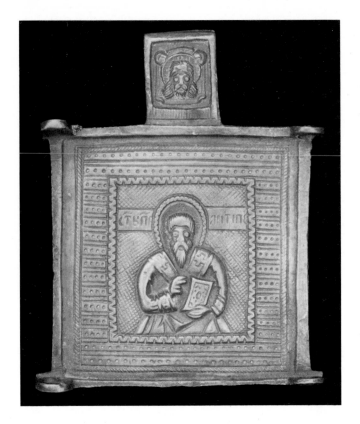

25819.133

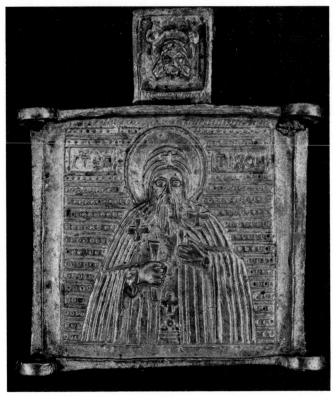

25819.135

21 Icon: Triptych with Finial 25819.133
 (central leaf only)
 SAINT ANTIP

Cast brass
H: 6.50; W: 4.8; T: 0.19
Eighteenth century
Negative number 88–1649–3

 Image finial has suspension loop on reverse. Wide-scored
and dotted border encloses hatched ground. OCS inscription
identifies frontal, half-length male figure as a "healer"; he holds
the Gospel in PL hand and extends two fingers of PR in
blessing.

 Microscopic study revealed red siliceous deposits; hatched
ground was often used as a base for enamel. This saint was
popularly held to be a healer of tooth problems.

22 Icon: Triptych with Finial 25819.135
 (central leaf only)
 SAINT TIKHON

Cast brass
H: 5.90; W: 4.60; T: 0.13
Nineteenth century
Negative number 87–5654–9

 Image finial and pintle hinge loops project from low-relief
surface. Both lateral leaves are missing. In the central leaf, a
frontal, half-length, bearded man holds a staff in PL hand, a
goblet in PR. A Greek cross appears on his stole, cowl, and
each shoulder. The ground contains Cyrillic letters at both sides
of head and an over-all pattern of horizontal lines and dots. This
type of textured background provided a good base for enamel.
The back has a loop for suspension.

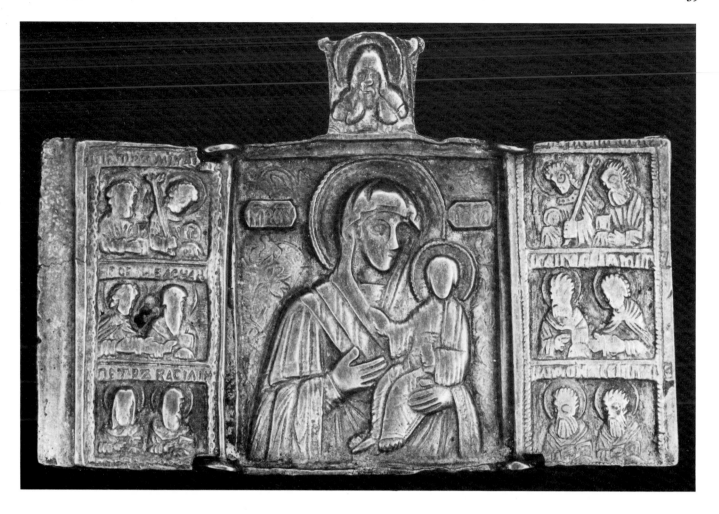

25819.136

23* Icon: Triptych with Finial 25819.136
The Smolensk Mother of God

Cast brass
H: 6.90; W: 10.10 (4.70 closed); T: 0.21
Eighteenth century
Negative number 87–5651–13

The Image finial and pintle-hung wings represent the same design, construction, and subjects as 25819.106 and 25819.130. In the central leaf, a frontal, half-length woman raises her PR forearm and turns her head toward an infant seated in her PL hand; a set of Greek-letter panels identify the pair as "The Mother of God" and "Jesus Christ." The ground displays inscribed leaves.

The faces are well-worn. The suspension loop on the back remains unpierced. The central back of the central leaf reveals a depression matching the front figures, and scratches from an earlier, inept cleaning.

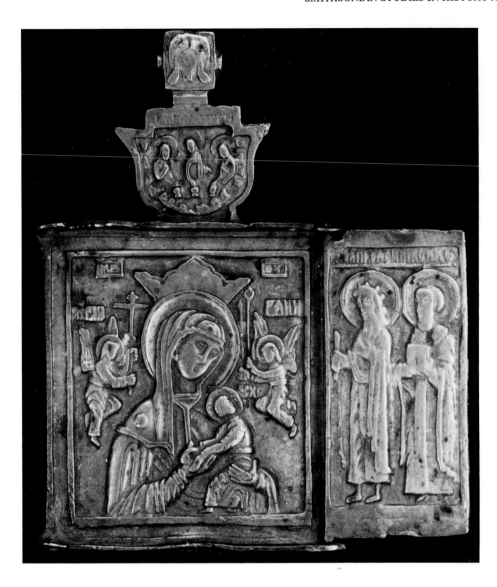

25819.139

24* Icon: Triptych with Crest and Finial 25819.139
 (PR wing missing)
 THE MOTHER OF GOD OF THE PASSION

Cast brass
H: 12.00; W: 10.00 (6.80 closed); T: 0.32
Probably seventeenth century
Negative number 87–5656–5

Finial and crest are similar in design and subject to 25819.099, except the seraphim heads are absent. In the central leaf, a half-length woman in robes and a scalloped crown turns to PL; her PL hand supports a seated infant Jesus, and her PR hand holds His hands. The sole of His PR foot is exposed, and He turns His head to look up to an angel carrying a spear and sponge, implements of His suffering and death, The Passion. An opposing angel carries a three-bar cross. Greek and Cyrillic letters appear in blocks. Hung on pintles, the surviving PL wing displays two standing figures identified by OCS inscriptions: St. John the Baptizer (PR) and St. Nicholas.

The Image finial is perforated for suspension. Bends in the upper and lower rim are probably from attachment nails. The back of the wing displays a hatched border.

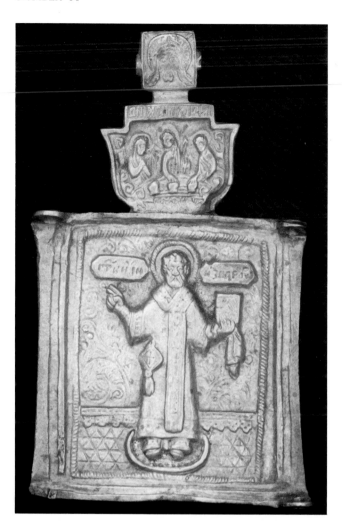

25819.140

25 Icon: Triptych with Crest and Finial 25819.140
 (central leaf only)
 SAINT NICHOLAS OF ZARAISK

Cast brass
H: 10.2; W: 5.80; T: 0.37
About 1700
Negative number 88–1647–1

Crest and finial similar in design and subjects to 25819.088, except the seraphim heads are absent; finial is pierced for suspension. *Skan'*-like border encloses a hatched and floral ground, and creates an aureole around the figure standing on a mat. He holds a cloth and the Gospel in extended PL hand and gives a blessing with PR. Figure is identified in OCS plaques at sides of head.

Reverse bears recessed image of the saint.

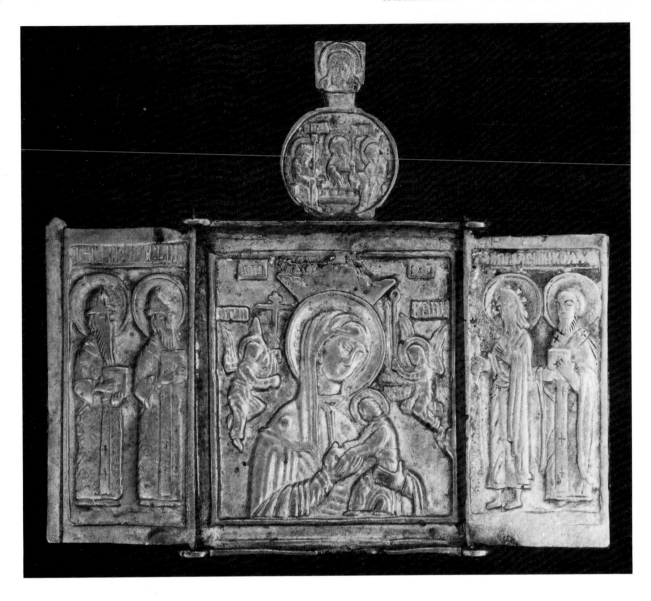

25819.141

26 Icon: Triptych with Crest and Finial 25819.141
THE MOTHER OF GOD OF THE PASSION

Cast brass
H: 11.60; W: 13.20 (6.50 closed); T: 0.26
Seventeenth century
Negative number 87–5650–31

Finial and crest are similar in design and subject to 25819.099, Image and Old Testament Trinity, but the crest is rounded into a disk and lacks the seraphim heads. Central leaf, PL wing, and pintles are the same in design and subject to 25819.139. The PR wing displays two standing male saints identified by OCS inscriptions as Barsonouphius, Bishop of Tver; and Gurik, the first archbishop of Kazan (see Jeckel,

page 50).

This icon underwent XRF analysis in 1985. Microscopic study revealed quartz from sand casting, and charcoal dust mold dressing (see Vera B. Espinola on icon manufacture). Lead corrosion products, caused by its high lead content, make this icon toxic to handle.

27 Icon: Triptych with Finial 25819.142
(central leaf only)
DEËSIS

Cast brass
H: 8.80; W: 6.20; T: 0.35
Seventeenth century
Negative number 87–5652–20

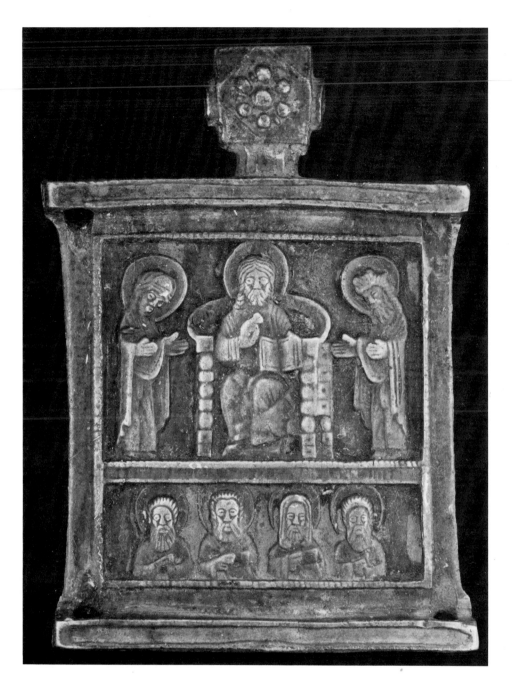

25819.142

The finial is a raised, flanged block with a seven-dot rosette. The central leaf is divided into two registers. The upper displays the Deësis subject: Jesus Christ enthroned in glory, accompanied by the Mother of God (PR) and St. John the Baptizer. The central, seated figure holds a book and raises His PR hand in blessing. The lower reigster contains four half-length figures of saints: (from PR) Sabbas, Nicholas, Leonty, and Zosima; each holds a scroll. Identifying inscriptions in OCS appear above both registers. The missing wings were hung on corner pintle rings, and the finial block was perforated for suspension.

XRF analysis (1985) gave alloy percentages as Cu 76.38, Sn 4.09, Pb 8.64 (relatively high), and Zn 9.84. Microscopic study recorded white molding material from a modern casting, red clay and other burial debris, and ethnographic candle wax, which had reacted with the copper to form copper oleates.

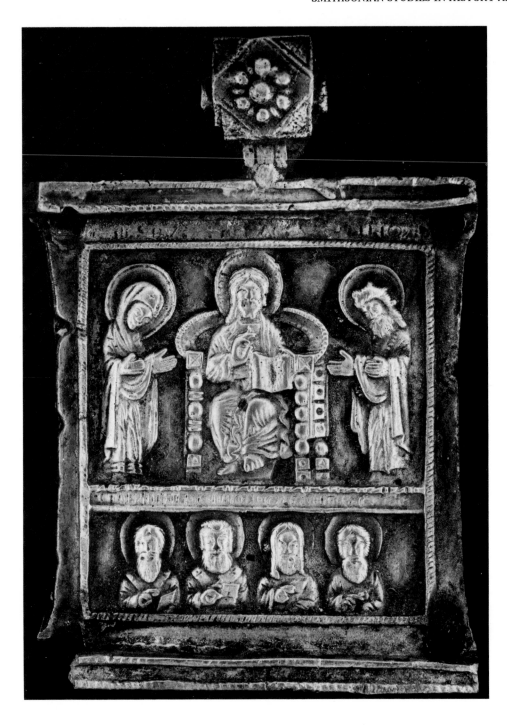

25819.143

28 Icon: Triptych with Finial
 (central leaf only)
 DEËSIS

Cast brass
H: 9.00; W: 6.20; T: 0.33
Seventeenth century
Negative number 87–5653–17

25819.143

This icon displays the same design, construction, and subjects as 25819.142.

The 1985 XRF analysis gave alloy percentages as Cu 78.55, Sn 5.55, Pb 3.73, and Zn 11.65. Top and side rims are bent, probably from nails used to hold the icon in place.

The back displays a rectangular outline. Microscopic study reveals burial debris, mold dressing of charcoal, quartz grains,

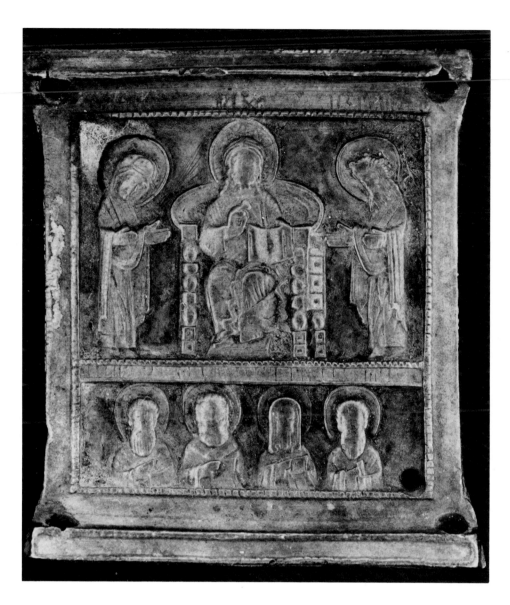

25819.144

and, on the base, candle wax, perhaps used to hold the icon in an upright position.

29* Icon: Triptych with Finial 25819.144
 (central leaf only)
 DEËSIS

Cast brass
H: 7.20; W: 6.20; T: 0.24
Seventeenth century
Negative number 87-5653-9

This icon displays the same design, construction, and subjects as 25819.142 and 25819.143.

The 1985 XRF analysis gave alloy percentages as Cu 89.76, Sn 4.14, Pb 5.32, and Zn 0.8. Microscopic examination revealed fractures in upper pintle sockets; burial debris of earth, textile, and wood; and bits of white molding material remaining from modern copying. The upper rim was distorted from nailing. The missing finial probably also displayed a rosette.

Careful comparison of the three *Deësis* icons reveals that one was not cast from the same mold, and that each was made from a different alloy. Despite these differences, the presence of similarly rounded quartz grains in these and in most of the other metallic icons in the Kunz collection, suggests a common environment, perhaps a burial zone near a lake or river in the Nizhnii Novgorod area.

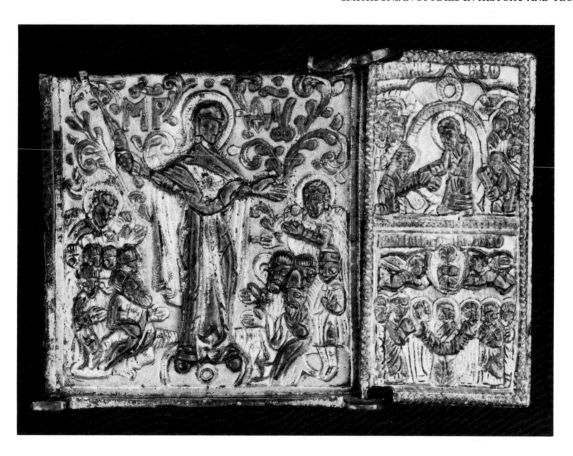

25819.146

30 Icon: Triptych (Crest and 25819.146
 PR wing missing)
 THE MOTHER OF GOD: JOY OF ALL WHO SORROW

Cast brass with gilding
H: 5.10; W: 7.70 (5.20 closed); T: 0.22
Eighteenth century
Negative number 87–5651–1

The central leaf and PL wing repeat the subjects, design, and construction of 25819.099, except tendrils replace hatching in the background of the central leaf.

A 1985 XRF analysis identified mercury, gold, copper, and a high zinc content (28%). The upper PR pintle ring is broken through and the PL wing is distorted, suggesting that the top of the center leaf was cut off. Microscopic study reveals evidence of a later re-gilding and also candle wax from its religious usage.

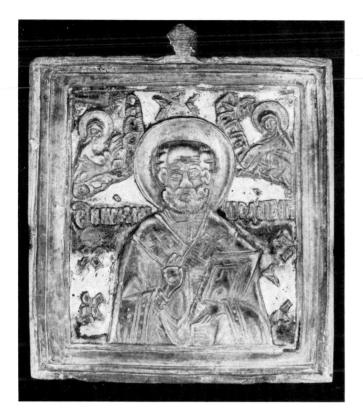

25819.156

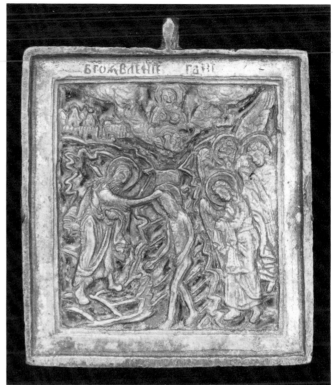

25819.169

31 Icon: Plaque with Knop 25819.156
 SAINT NICHOLAS THE WONDERWORKER

Cast brass with gilding under blue enamel
H: 6.20; W: 5.30; T: 0.35
Nineteenth century
Negative number 87–5655–24

A facetted knop is pierced for suspension. The plaque bears the same subject as the PR wing of 25819.066, as well as a similar design, except the lower, flanking figures are replaced with an asymmetrical pattern of square-petal rosettes.

32 Icon: Plaque with Knop 25819.169
 THE BAPTISM OF JESUS CHRIST

Cast brass with blue enamel
H: 5.60; W: 4.90; T: 0.37
Nineteenth century
Negative number 88–1648–24

The knop is not pierced. God the Father and the Holy Spirit (symbolized by a dove) appear in reserve in top center. In landscape below are several figures. The one at PR, St. John the Baptizer, pours water over the head of Jesus, who stands in a stream, the River Jordan. Three angels representing the choirs of Heaven appear on PL. An OCS inscription on the upper border proclaims *Bogoiavlenie,* "manifestation" (of Jesus as Son of God).

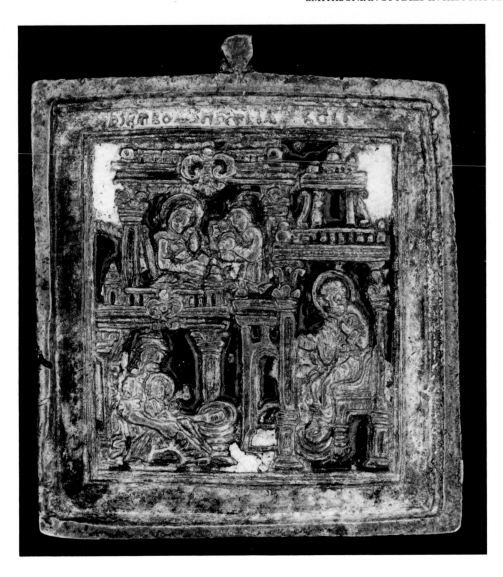

25819.174

33 Icon: Plaque with Knop 25819.174

THE NATIVITY OF THE MOTHER OF GOD

Cast brass with blue and white enamel
H: 6.10; W: 5.20; T: 0.40
Nineteenth century
Negative number 87–5654–17

The facetted knop is not pierced for suspension. The top of the wide frame carries an inscription in OCS. The design presents an architectural setting of five figures in three spaces. On PR are two chambers, one above the other, both of which are framed with wide cornices and columns. The upper PR chamber shows St. Anne in a birthing bed with an attendant; the lower room reveals an attendant bathing an infant. On PL is a tall room with an aedicule crest containing a single seated figure, St. Anne, the mother of Mary, the Mother of God.

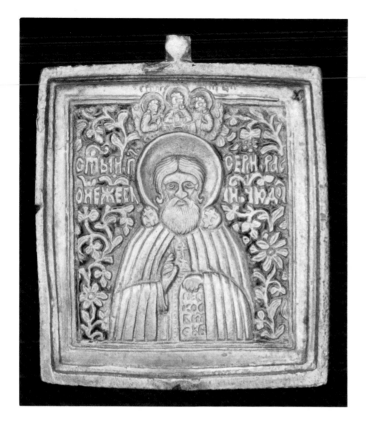

25819.181

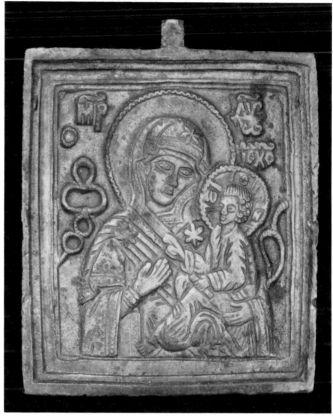

25819.198

34 Icon: Plaque with Knop 25819.181
SAINT SERGIUS OF RADONEZH

Cast brass with blue enamel
H: 6.30; W: 5.30; T: 0.37
Nineteenth century
Negative number 88–1648–32

The knop is not pierced. The double-recessed border of the plaque is interrupted at the top center by an image of the Holy Trinity rising from the aureole of a 3/4-length male figure. At his neck appears a "great schema," a garment indicating high ascetic achievement. The open scroll in his PL hand begins with "Be not sorrowful...." The OCS inscription on the floral background identifies the saint as a "miracle worker." Saint Sergius founded the Holy Trinity Monastery in Sergeiev posad, now the center of the Russian Orthodox Church in the U.S.S.R.

The reverse is decorated with an incised design of a medallion surrounded by corner rosettes nearly linked by floral arabesques. This design and its hatched ground are enclosed by a deep border of grooves, dots, and a spiral.

35 Icon: Plaque with Knop 25819.198
THE TIKHVIN MOTHER OF GOD

Cast brass
H: 6.30; W: 5.10; T: 0.38
Nineteenth century
Negative number 88–1649–15

The knop is not pierced. A quadruple-recessed border encloses a hatched ground and relief *skan'*-like ornamentation. In this advocation, the Mother of God is shown as a 3/4-length figure with covered head. A six-point star is on her forehead and shoulders. She faces, slightly to PL, where a frontal, 3/4-length Infant Jesus sits upon her PL forearm. The sole of His PR foot appears beneath His gown, and His PR hand rises in a blessing. Greek and Cyrillic letters identify the figures.

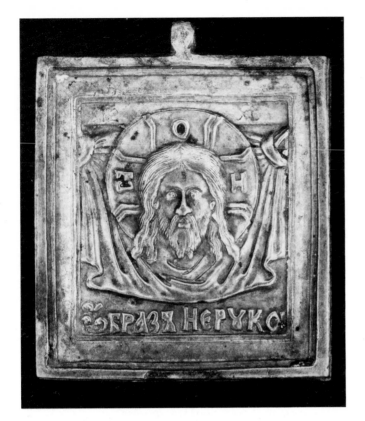

25819.201

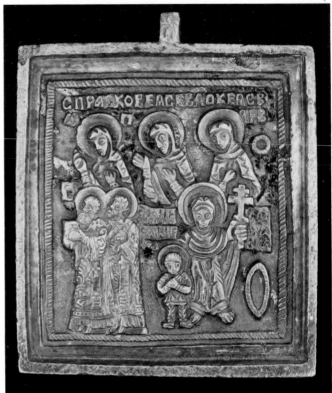

25819.206

36 Icon: Plaque with Knop 25819.201
THE IMAGE NOT MADE WITH HANDS

Cast brass
H: 6.20; W: 5.20; T: 0.30
Nineteenth century
Negative number 87–5649–35

The facetted knop is partially pierced for suspension. The traditional design shows the frontal face of a bearded man, Jesus Christ, imposed on a cloth with knotted, upper corners. Greek letters appear in the cross of the halo; an OCS inscription runs along the base.

Beginning with cross 25819.026 and icon 25819.088, this popular motif is cited in the Glossary and in Lefchick's chapter on iconography.

37* Icon: Plaque with Knop 25819.206
SAINTS JULITTA AND CYRICUS AND FIVE SAINTS (THE SEVEN SAINTS)

Cast brass with gilding under blue and white enamel
H: 5.90; W: 5.00; T: 0.48
About 1800
Negative number 87–5655–21

The knop is not pierced. The design and subjects are the same as PL leaf of 25819.066, except the two rosettes in the lower PL corner are replaced by a vertical lozenge, and the rosette above, by a circle. Both are of twisted wire design, as in the inner border.

Microscopic study observed a modern white molding material on both sides; this later material accelerated bronze disease and a loss of enamel.

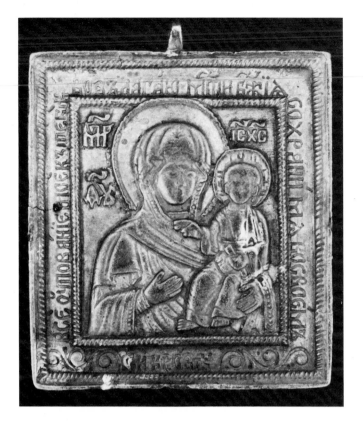

25819.217

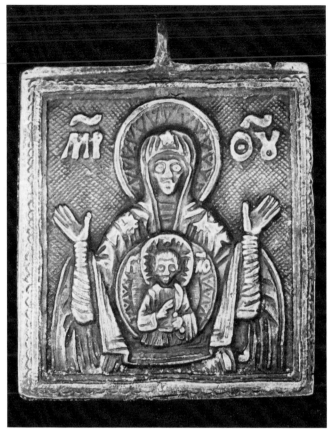

25819.220

38 Icon: Plaque with Loop 25819.217
THE SMOLENSK MOTHER OF GOD

Cast brass
H: 5.60; W: 4.80; T: 0.27
Probably eighteenth century
Negative number 87–5654–1

The loop is pierced for suspension. The design is of a frontal, half-length woman raising her PR forearm and turning her head toward the infant Jesus seated in her PL hand; a set of Greek-letter panels identify the pair. This plaque also adds an encircling OCS inscription: "All my hope in you/ I place, Mother of God;/ Keep me in your/ Protection."

39 Icon: Plaque with Loop 25819.220
THE MOTHER OF GOD OF THE SIGN

Cast brass
H: 6.30; W: 4.20; T: 0.21
Eighteenth century
Negative number 87–5658–17

The loop is pierced for suspension. The design presents a frontal, half-length figure of an orans-type woman, her forearms raised in prayer. Between her arms appears a frontal, half-length child in an aureole; this figure of Jesus holds a scroll in His PL hand and raises His PR in blessing. Large Greek letters flank the Mother's head. The ground is hatched and may have been enameled at one time.

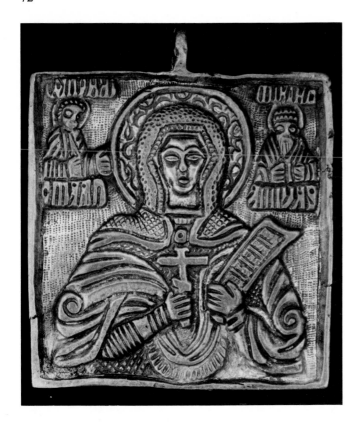

25819.223

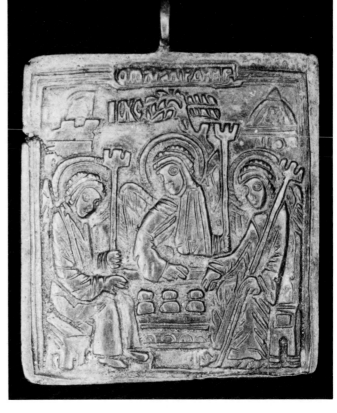

25819.225

40 Icon: Plaque with Loop 25819.223
Saint Paraskeva Piatnitsa

Cast brass, originally enameled
H: 5.30; W: 4.50; T: 0.26
Probably eighteenth century
Negative number 87–5659–24

The loop is pierced for suspension. The subject is the same as the central leaf of 25819.057, but in this icon, the saint holds up a three-bar cross in her PR hand and in her PL, a scroll beginning with the Nicene Creed, "I believe in...." A half-length figure of a saint appears at each side of her head. The ground bears a pattern of dotted depressions.

Microscopic study reveals remains of blue enamel in the PR corner at the base. The icon background was once enameled.

41 Icon: Plaque with Loop 25819.225
The Holy Trinity

Cast brass
H: 5.10; W: 4.00; T: 0.23
Probably eighteenth century
Negative number 87–5658–9

The loop is pierced for suspension. The icon may have been gilded and enameled at one time. The subject is the same as in a panel on cross 25819.006, in icon 25819.055 (crest B), and the crest of 25819.088. Three winged figures, each with a three-prong staff, sit on stools around a table with six cakes. Behind them appear crenellated walls and a dome.

The subject is based on a traditional Russian interpretation of Genesis:18, in which three figures appear to Abraham at the oak tree of Mamre: the central figure is Jesus Christ; God the Father is on PR; the Holy Spirit is on PL.

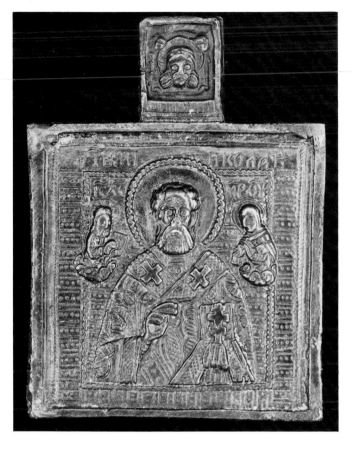

25819.226

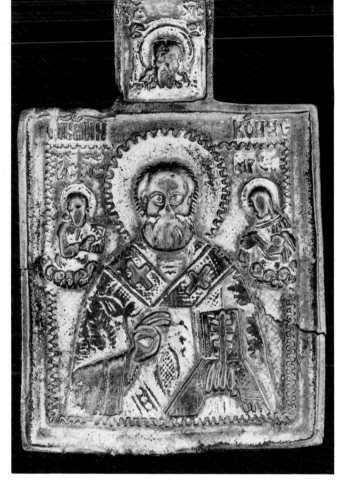

25819.227

42 Icon: Plaque with Finial 25819.226
SAINT NICHOLAS THE WONDERWORKER

Electrotype copper; plated with tin-lead solder on reverse
H: 6.30; W: 4.70; T: 0.16
About 1850 to 1890
Negative number 87–5654–13

The Image finial and patterned ground repeat 25819.135. The subject is that of 25819.156, but the OCS inscription has been raised above the saint's head, and a three-bar cross replaces the book in his PL hand.

Microscopic study revealed a white polymeric molding material on both sides, suggesting a post-1946 copying. The icon is electroplated, showing copper with a lead-tin solder on the back; the copper face is artificially patinated to appear older. The icon represents the deterioration of the craft when rapid manufacturing methods were introduced to meet an increased demand. The absence of a suspension loop suggests that this later icon was not intended to be worn around the neck.

43 Icon: Plaque with Finial 25819.227
SAINT NICHOLAS THE WONDERWORKER

Cast brass, mercury gilded
H: 6.50; W: 4.30; T: 0.46
Eighteenth century
Negative number 87–5655–30

The subjects of the finial and plaque are the same as 25819.226, but the ground is hatched rather than textured with horizontal lines and dots.

Top and bottom rims are bent from attaching nails. The back shows an indentation approximating the front design.

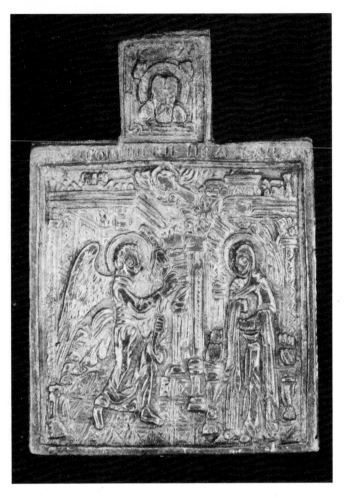

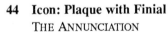

25819.230

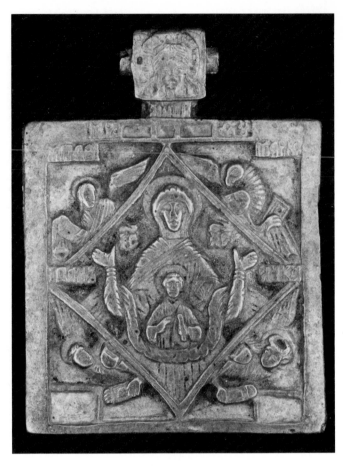

25819.245

44 Icon: Plaque with Finial 25819.230
THE ANNUNCIATION

Cast brass
H: 5.90; W: 4.00; T: 0.31
Eighteenth century
Negative number 87–5659–28

The finial subject is again the Image, as on 25819.227. A worn OCS inscription occurs on the upper frame. The plaque design shows a room divided by a column and decorated with cornice, wall panels, and floor tiles. At the top, a dove, symbolizing the Holy Spirit, beams light down onto a woman standing on PL, the Mother of God. The archangel Gabriel approaches her on PR.

The impact of Renaissance art is seen in the naturalism of posture and drapery and in spatial perspective. White molding material suggests that a copy was made of the icon.

45 Icon: Plaque with Finial 25819.245
THE MOTHER OF GOD OF THE BURNING BUSH

Cast brass
H: 6.90; W: 5.10; T: 0.30
Eighteenth century
Negative number 87–5653–1

The Image finial is raised and perforated for suspension. The central design presents a diamond in a square. In the center, a 1/2-length, frontal figure of a woman repeats the subject of 25819.220, the Mother of God of the Sign; but the small figure appears on a twisted part of her mantle. In each corner triangle is a symbolic winged figure (clockwise from upper PR): angel, eagle, calf, and lion. The identity of each saintly evangelist appears in OCS: Matthew, Mark, Luke, and John. The emblems for Mark and John were officially reversed in Russian Orthodox practice after 1666 and the animal emblems were reduced to figures with human faces by church order in 1722 (Printseva, 1986:62). A well-known "Hymn to the Mother of God" from eighth century Constantinople refers to her as a "burning but unconsumed bush," relating to her virginity (Jeckel, 1981:90).

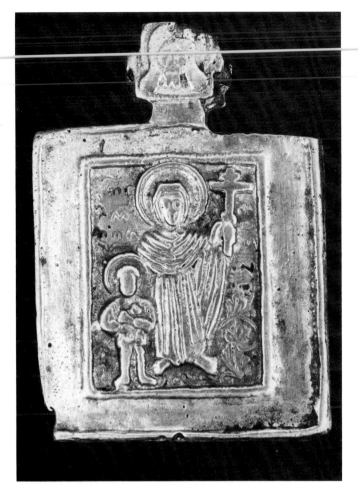

25819.249

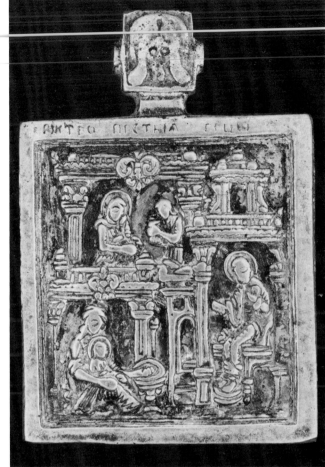

25819.251

46 Icon: Plaque with Finial 25819.249
SAINTS JULITTA AND CYRICUS

Cast brass
H: 5.80; W: 4.20; T: 0.36
Eighteenth century
Negative number 87–5659–32

The raised, Image finial is pierced for suspension. The subject isolates the main figures of 25819.130 in a wide frame. A floral motif appears in the lower PL corner. Casting failures appear in the finial and lower PR corner.

47* Icon: Plaque with Finial 25819.251
THE NATIVITY OF THE MOTHER OF GOD

Cast brass
H: 6.50; W: 4.50; T: 0.39
Eighteenth century
Negative number 87–5655–32

The subject is the same as 25819.174, but the knop has been replaced with a raised, Image finial pierced for suspension. The OCS inscription at the top reads, "The birth of the most holy Mother of God."

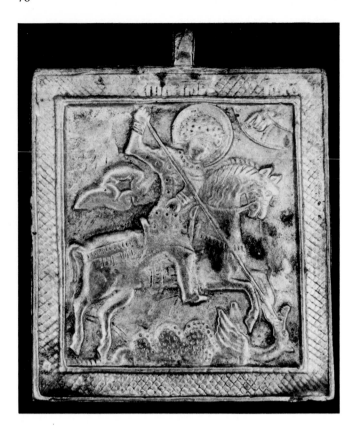

25819.254

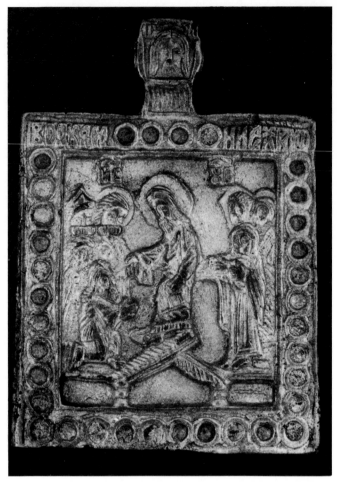

25819.262

48 Icon: Plaque with Loop 25819.254
 SAINT GEORGE SLAYING THE DRAGON

Cast brass
H: 7.40; W: 6.20; T: 0.33
Early eighteenth century
Negative number 87–5653–12

 The loop is pierced for suspension. The plaque displays a
man astride a leaping horse. He is seated in a high-ended saddle
secured by breast, rump, and belly straps. With his raised PR
arm, he plunges a spear into the mouth of a coiled dragon.
Between two arcs in the upper, PL corner appears the PR hand
of Jesus Christ giving a blessing. Dots give texture to the saint's
hair and the dragon's body, and hatching fills the wide frame.
 The back reveals a raised edge and an outline of the frame.

49 Icon: Plaque with Finial 25819.262
 THE RESURRECTION (also known as THE DESCENT
 INTO HADES)

Cast brass
H: 6.30; W: 4.40; T: 0.29
Seventeenth century
Negative number 87–5654–5

 The Image finial is raised on a fluted post. The plaque
displays a central figure of Jesus Christ, stepping to His PR and
bending toward a kneeling man, Adam. There are three
standing figures on PL and a winged figure on PR. The thick
groundline rests on two supports and peaks in the center. The
top of the frame, decorated with large circles, carries the OCS
inscription, "The Resurrection of Christ." The subject is
repeated in 25819.055 and in the upper scene of PL wing of
25819.057, 25819.088, 25819.099, 25819.101, and 25819.146.

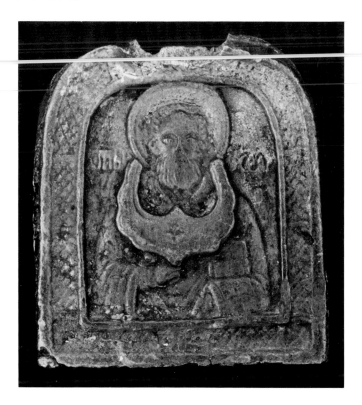

25819.268

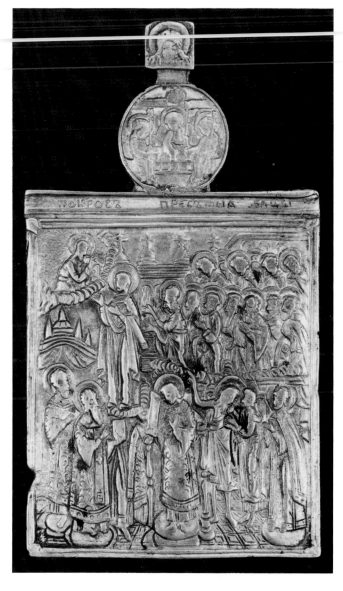

25819.269

50 Icon: Plaque 25819.268
SAINT NICHOLAS THE WONDERWORKER

Cast brass
H: 4.30; W: 3.90; T: 0.34
Seventeenth century
Negative number 87–5658–3

A crest or finial is broken off. The sides of the plaque slant inward and the upper corners are rounded. The central figure is a frontal, half-length, bearded man wearing a scalloped yoke, *tsata*. He holds the Gospel in his PL arm. Cyrillic letters appear at his shoulders. The wide frame is hatched, similar to 25819.254.

In the Kunz collection, this design of St. Nicholas appears less often than others, but the subject is second in frequency only to that of the Mother of God.

51 Icon: Plaque with Crest and Finial 25819.269
THE PROTECTION OF THE MOTHER OF GOD

Cast brass
H: 13.30; W: 7.50; T: 0.36
Seventeenth century
Negative number 87–5652–28

The design and subject of the crest and finial are the same as 25819.141. The top of the frame carries an OCS inscription. In the scene, 21 figures appear in two registers; most face PR. In the upper, PR corner, a half-length figure of Jesus Christ radiantly faces a woman with raised hands; behind her are a throng of 13 saints. Below appear six figures, more widely spaced; three face PL. The floor is set with rounded stands and covered with tiles in perspective.

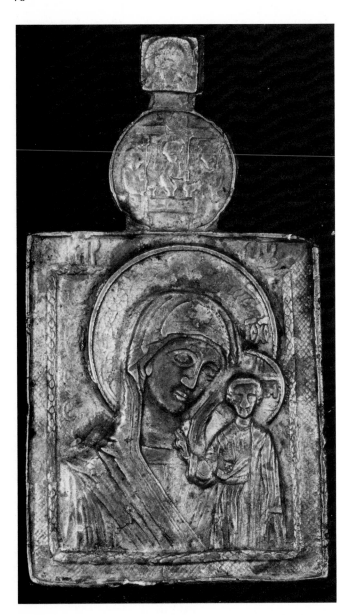

25819.271

52 Icon: Plaque with Crest and Finial **25819.271**
The Kazan Mother of God

Cast brass
H: 11.70; W: 6.60; T: 0.39
Seventeenth century
Negative number 87–5652–24

Crest and finial design and subjects are the same as 25819.141 and 25819.269. Within a hatched frame appears the bust of a woman with her head tilted and turned to PL. There stands a small, 3/4-length figure of Jesus Christ with His PR hand raised in blessing. Both figures are identified in Cyrillic and Greek letters above their heads.

As on other metallic icons, the design is derived from a very popular, older image painted on wood; the image for this devotion was originally located in the city of Kazan.

53 Icon: Plaque with Gallery **25819.273**
Jesus Christ Enthroned: King of Glory

Cast brass
H: 16.30; W: 10.00; T: 0.51
Nineteenth century
Negative number 87–5652–31

The pierced crest consists of six seraphim heads raised on posts. A shield appears in the top, center of the leaf-engraved frame. Within the shield is seen God the Father as He appears in 25819.003, with raised arms and an orb with a three-bar cross. Below Him is a small diamond with a dove, symbolizing the Holy Spirit. In the main scene, Jesus Christ is seated in a scalloped-back throne. He is flanked by eight standing and four kneeling figures of saints. At His feet are Nicholas and Basil (PR) and Sergius and Savatii. Standing on PR are John the Evangelist, Peter, archangel Michael, and the Mother of God holding a scroll; on the PL are Paul, John Chrysostom, archangel Gabriel, and John the Baptizer, also with a scroll. OCS inscriptions identify most of the figures, including that in the shield as the "Lord of Hosts."

Each side has dents, probably from attachment nails.

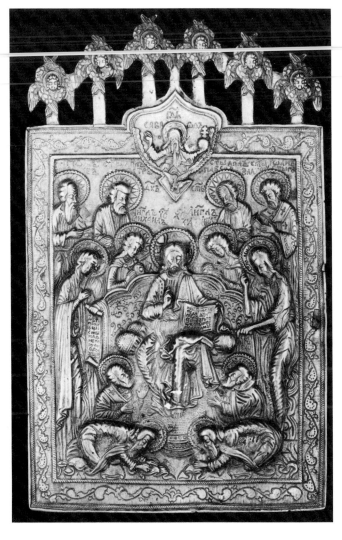

25819.273

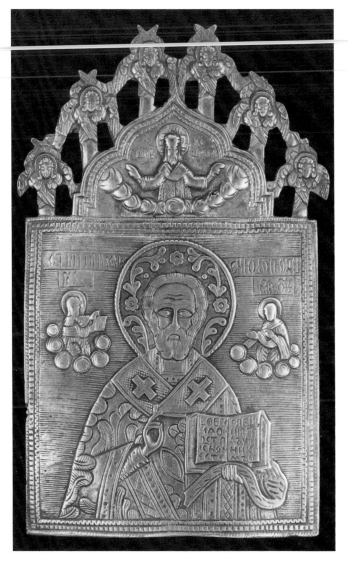

25819.279

54 Icon: Plaque with Crest and Gallery 25819.279

SAINT NICHOLAS THE WONDERWORKER

Cast brass
H: 12.60; W: 7.60; T: 0.28
Early nineteenth century
Negative number 87–5662–31

A pierced gallery, similar to 25819.273, crowns a raised, ogee-arch crest recalling those on 25819.057. Greek and OCS inscriptions identify the figure with open arms as "Jesus Christ/King of Kings." The main subject of the plaque is that of 25819.156, 25819.226, 25819.227, and 1986.0574.01.

The treatment of the subject is the most crisp in the collection.

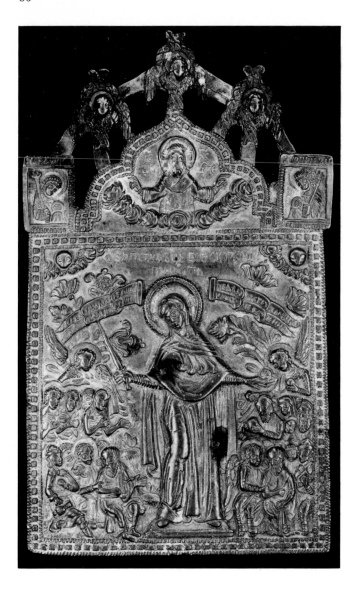

25819.281

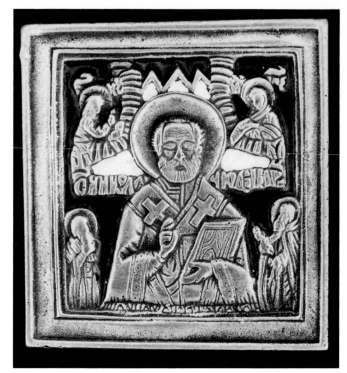

1986.0574.01

inscriptions, and fifteen small figures of saints and angels.

The back shows a depression of the front design, and a suspension loop.

56 Icon: Plaque** 1986.0574.01
SAINT NICHOLAS THE WONDERWORKER

Cast brass-colored metal with red and white champlevé enamel
H: 5.10; W: 4.80; T: 0.85
Late twentieth century
Negative number 87–5659–36

The subject repeats the PR leaf of 25819.066, 25819.156, 25819.226, and 25819.227. The back displays a small suspension loop and the stamp of the maker: G-in-square.

This was made in Rhode Island by the Greenbriar Company and acquired by the Smithsonian Institution in 1986. The worn faces of the corner figure suggests that an older metal-alloy icon was used as the model for the new casting, and only the face of St. Nicholas on the original was reworked before it was used as a casting model.

57 Icon: Plaque with Gallery** 1982.0007.31
THE PROTECTION OF THE MOTHER OF GOD

Cast brass
H: 13.3; W: 10.7; T: 0.335
About 1800
Negative number 88–1650–28

55 Icon: Plaque with Crest and Gallery 25819.281
THE MOTHER OF GOD: JOY OF ALL WHO SORROW

Cast brass
H: 13.60; W: 8.10; T: 0.33
Eighteenth century
Negative number 87–5660–35

The gallery is similar to 25819.279, but reduced to three seraphim heads. The design and subject of the ogee-arch crest is the same as 25819.279, except that a panel has been added at each upper corner. Each displays a half-length, inward-facing figure holding a three-prong staff and a disk; they represent the archangels Michael (PR) and Gabriel. The main subject repeats 25819.099 and 25819.146, but here the head of the Mother of God turns to PR. Also, the sun and moon appear in the upper corners. Below them are large blossoms, two banners with OCS

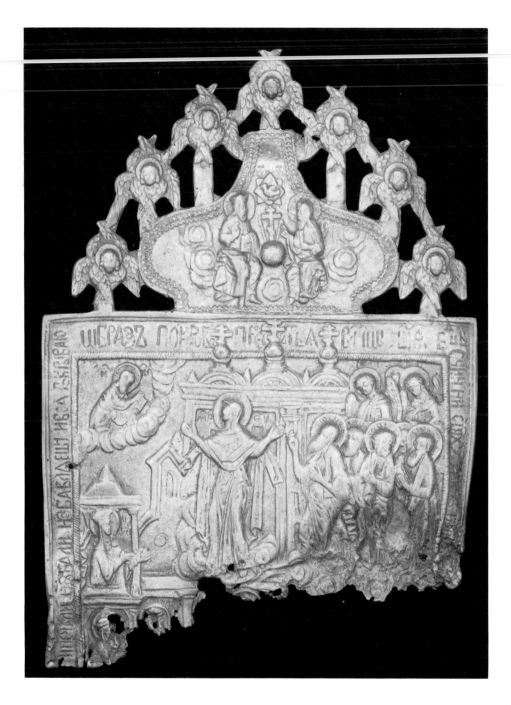

1982.0007.31

Seven seraphim frame a modified *kokoshnik* (*bochka*) crest with a geometric border. The crest depicts a noncanonical trinity: God the Father and God the Son sit facing each other across an orb and crucifix; a dove, symbolizing the Holy Spirit, hovers above the crucifix.

A wide border around the plaque is covered with OCS inscriptions. Hands outstretched, the Mother of God stands slightly PR from the center of the plaque, looking toward God the Son in the upper PR corner. "Clouds" at her feet and around the upper PR corner signify spiritual rather than material presence. Five saints stand at the PL; three angels, one depicted only by a halo behind the other two angels, stand behind and above the saints. Below at the PR edge, a smaller haloed figure, Saint Helena, appears under a canopy.

The lower portion of this plaque is missing, the result of a "cold shot" casting, when the molten metal flowed incompletely into the mold. Nevertheless, candle wax and patterns of wear indicate that the icon was placed into reverent use.

Glossary

aedicule.—In art, a small, temple-like facade used as a crest.

apocryphal.—Based on texts or oral traditions whose historical authenticity is dubious.

aureole.—Radiance from head or figure of sacred person.

bochka.—Russian for barrel, refering to an arched crest shape on an icon.

brass.—Metal alloy of copper and zinc, with other trace elements.

bronze.—Metal alloy of copper and tin.

Byzantine.—Pertaining to the Christian Roman Empire initiated by Constantine the Great in A.D. 330, and lasting until the fall of Constantinople in 1453.

Byzantium.—Ancient name of the Greek city-state founded in the eighth century B.C. at the junction of the Golden Horn and the Sea of Marmara.

canon.—From Greek, meaning "rule" or "standard" by which to measure or evaluate something.

canonical.—Applied to icons, it means that they conform to the early theological and esthetic requirements of the Orthodox church.

ciborium.—A structure made up of four pillars supporting a dome set above the altar of early Orthodox churches.

corpus.—Latin for "body," referring to the crucified figure of Jesus on the cross.

crest.—A decorative motif that surmounts the main body of an art object.

Cu.—The chemical abbreviation for copper.

Deësis.—Greek for "prayer," used as title for icons showing Jesus Christ in glory with *Theotokos* (see below) to His right and St. John the Baptizer to His left, both turned toward Him in an attitude of prayer.

dominical.—From Latin, "Dominus," pertaining to "the Lord."

dormition.—A reference to death as "falling asleep," as in the iconographic subject "Dormition of the Mother of God."

egg tempera.—Traditional paint for Orthodox icons in which egg yolk is used as the binding medium.

fresco.—Painting executed on plaster.

God Sabaoth.—From the Hebrew, *tsebaoth,* plural of *tsaba,* army; hosts.

Golgotha.—Hebrew for "place of the skull," referring to the location of the crucifixion of Jesus Christ.

Great Fast.—A period of fasting beginning seven weeks before Easter in the Orthodox church.

hagiography.—Writings describing the lives of the saints.

Hodigitria.—Greek for the icon subject depicting the Mother of God holding Jesus as the "Christ child" in a formal, regal posture.

icon.—Greek for "image," a sacred representation for the Orthodox church.

IC XC.—Greek- and Russian-letter abbreviation for "Jesus Christ." It is shown on Old Greek icons.

Image.—Fully, "The Image Not Made with Hands," the popular iconographic subject depicting the face of Jesus Christ on a cloth used to wipe it on His way to Golgotha; also known as "Veronica's Veil" from the Latin for "true icon."

kenosis.—Greek for "self-abasement," used in the New Testament to describe Jesus Christ's acceptance of the human condition and death.

kokoshnik.—A Russian term for a headdress and for an ogee arch; a modified form of the arch is barrel-shape and is called a *bochka.*

leaf.—A single panel of a triptych (see below).

mandorla.—An iconographic convention of a circle or oval symbolizing the spiritual glory of the figure it surrounds.

metanoia.—Greek word referring to a radical change in one's heart and way of life.

Metropolitan.—Primate of an ecclesiastic province.

mosaic.—Design built up with small pieces of colored stone, glass, etc. set in cement.

OCS.—Abbreviation for Old Church Slavonic, the language using Cyrillic letters to form most inscriptions on Russian icons.

ogee.—In art, a reverse curve, often opposed to create an arch called *kokoshnik* in Russian, applied to an icon's crest or outline of an onion-shape dome.

Old Testament Trinity.—A subject represented by three angles that is generally identified as the Holy Trinity. [For an explanation of the canonical versus noncanonical image of the Trinity see page 24. R.E.A.]

omophorion.—In the Orthodox church, a bishop's principal vestment; a *pallium* in the Roman Catholic church.

orans-type.—A gesture of supplication; a figure with arms outstretched in supplication.

Orthodox Catholic church.—Phrase identifying mainstream Christianity of the east, developed during the post-Constantinian era of doctrinal disputes.

Palladium.—From the Greek, a sacred image believed to protect its host city.

Pantocrator.—From Greek for "all powerful," applied to an image of Jesus Christ when His awesome features suggest the image of God the Father.

Pb.—The chemical abbreviation for lead.

phylactery.—On a typical Russian cross, the top, horizontal bar representing the plaque Pilate had nailed to it; in the Latin Church, it bears "INRI."

piano hinge.—The articulation of two pieces secured by a pin run through a series of small cylinders alternately attached to each side.

pintle.—A pin or a bolt, especially one upon which something turns, as in a hinge.

PL and PR.—Refer objectively to "proper left" and "proper right" side of an object, often opposite to a viewer's side.

plaque.—A single plate, without side leaves or wings.

Radost.—A Russian term for the Mother of God as the "Joy of All Who Sorrow."

register.—In art, a horizontal band that appears above another.

Resurrection.—Iconographic subject also called "The Descent into Hades," the subject is the visitation of Jesus Christ to a dark region and His rescue of Adam.

Russian Orthodox church.—The official state religion of Russia from A.D. 988 to 1917.

seraphim.—Six-winged angels of the highest rank believed in ancient Judaism to guard God's throne.

skan'.—A round or flattened silver, gold, or gilded silver wire, either twisted or braided, used to outline enamels or to embellish metalwork.

skit.—A religious community; an hermitage.

Sn.—The chemical abbreviation for tin.

sprue marks.—Residual impressions on metal caused by an opening in a mold into which molten metal was poured.

suppedaneum.—Greek for the foot support represented by the slanted lowest bar on a Russian cross.

Theotokos.—Greek for "Mother of God" and endorsed as a technical theological term by the third ecumenical Council of Ephesus in A.D. 431.

three-bar cross.—The typical Russian cross, also called "eight-ended."

triptych.—An art object consisting of three panels, either overlapping when closed, or with two lateral wings half the width of the central panel.

uezd.—An old Russian term for a small geographic entity, such as a region or area.

ukaz.—Usually rendered in English as *ukase;* it is an official decree or edict, usually by the Tsar or other high authority.

umileniye.—Russian for "loving-kindness," used as a title for icons of the Mother of God and Child dominated by an expression of intimacy and tenderness.

wing.—One of the two lateral panels of a triptych.

Zn.—The chemical abbreviation for zinc.

References

HISTORICAL BACKGROUND

Billington, James H.
1966. *The Icon and the Ax: An Interpretive History of Russian Culture.* New York: Alfred A. Knopf.

Crummey, Robert O.
1970. *The Old Believers and the World of the Anti-Christ: The Vyg Community and the Russian State, 1699–1855.* Madison: University of Wisconsin Press.

Fedotov, G.P.
1960. *The Russian Religious Mind.* New York: Harper and Row, Publishers.

Mel'nikov, P.I.
1910. "Otchet o sovremennom sostoianii raskola v Nizhegorodskoi gubernii." *Deistviia Nizhegorodskoi Gubernskoi uchenoi arkhivnoi komissii, part 2,* 10:1–155.

Riasanovsky, Nicholas V.
1969. *A History of Russia.* 2nd edition. New York: Oxford University Press.

Runciman, S.
1975. *Byzantine Style and Civilization.* Middlesex, England: Marmondsworth. [Also see 1981 edition published by Penguin Books.]

Sherard, P.
1966. *Byzantium.* New York.

EASTERN ORTHODOX ICONS

Alpatov, V.M.
1977. *Frescoes of the Church of the Assumption at Volotovo Pole.* Moscow: Isskustvo.

Antonova, V.I., and N.E. Mneva
1963. *Katalog drevnerusskoi zhivopisi.* 2 volumes. Moscow: Isskustvo.

Bank, A.
1965. *Byzantine Art in the Russian Collection.* Moscow.

Beckwith, J.
1961. *The Art of Constantinople.* London: Penguin Books.
1979. *Early Christian and Byzantine Art.* London: Penguin Books.

Cavarnos, C.
1977. *Orthodox Iconography.* Belmont: Massachusetts Institute for Byzantine and Modern Greek Studies.

Danilova, I.
1970. *The Frescoes of St. Pherapont Monastery.* Moscow: Isskustvo.

Espinola, Vera B.
1987. "The Technical Examination of Russian Icons and Oklads." In *International Council for Museums (ICOM) Committee for Conservation, 8th Triennial Meeting, Sydney* [Preprint], 3:1105–1108.

Grabar, A.
1953. *Byzantine Painting.* New York.

Jääskinen, Aune
1984. *Ikonimaalari uskon ja mystikan tulkki.* Helsinki.

Kontoglou, P.
1960. *Ekphrasis tes orthodoxou eikonographias.* 2 volumes. Athens.

Lazarev, Victor N.
1969. *The Novgorod School of Icon Painting.* Moscow: Isskustvo.
1971. *The Moscow School of Icon Painting.* Moscow: Isskustvo.

Nikolayeva, T.V.
1977. *Drevnerusskaia zhivopis' zagorskovo muzeia.* Moscow: Isskustvo.

Ouspensky, L., and V. Lossky
1952. *The Meaning of Icons.* Basle, Switzerland: Otto Walter, Ltd.

Pleshavona, I.V.
1985. *Drevnerusskoe dekorativno-prikladnoe isskustvo v sobranie Gosudarstvenogo Russkogo Muzeia.* Leningrad: Iskusstvo.

Rice, D.T.
1962. *Byzantine Art.* London.
1963. *Art of the Byzantine Era.* New York.

Salko, N.
1982. *Early Russian Painting.* Leningrad.

Saltykov, A.A.
1982. *Muzei Drevnerusskogo iskusstva imeni Andreia Rubleva.* Leningrad.

Schug-Wille, C.
1969. *Art of the Byzantine World.* New York.

Trubetskoi, E.N.
1973. *Icons: Theology in Color.* New York.

Vzdornov, G.
1972. *Art of Ancient Vologda.* Leningrad.
1976. *Freski feofana greka v tserkvi spasa preobrazheniya v Novgorode.* Moscow.

Z.E.Z.
1986. "Ob ikonakh Sviatitelia Nikolaia, chudotvortsa Rossiiskogo." *Koster* [Bulletin Interieur de l'Association des Vitiaz, Paris], 141(June):8–13.

RUSSIAN COPPER ICONS

Belen'kaya, D.A.
1976. "Kresti i ikonki iz kurganov Podmoskov'ia." In *Sovetskaya Arkheologia, Akademiya Nauk,* 4. Moscow.

Casanowicz, Immanuel Moses
1929. "Ecclesiastical Art of the Eastern Church." *In* Collections of Objects of Religious Ceremonial in the United States National Museum. *USNM Bulletin,* 148. Washington, D.C.

Dal', L.V.
1874. "Zametki o mednikh grivnakh XII veka." *Trudy Moskovskago Arkheologicheskago Obshchestva.* Second edition, volume 4. Moscow.

Druzhinin, V.G.
1926. "K istorii krest'ianskogo iskusstva XVIII-XIX vekov v Olonetskoi gubernii (Khudozhestvennoe nasledie Vygoretskoi Pomorskoi obiteli)." *Izvestiia Akademii Nauk USSR.* pages 1483–1488.

Espinola, Vera B.
1984. "Russian Metal Icons in the Smithsonian Institution." In *International Council for Museums (ICOM) Committee for Conservation, 7th Triennial Meeting, Copenhagen* [Preprint], volume 2, pages 84.23.1, 84.23.2.

Jeckel, S.
1981. *Russische Metall-Ikonen in Formsand gegossener Glaube.* Bransche, Federal Republic of Germany: Verlag Gebr. Rasch.

Jones, Charles W.
1978. *Saint Nicholas of Myra, Bari, and Manhattan: Biography of a Legend.* Chicago: University of Chicago Press.

le Berrurier, Diane
1988. "Icons from the Deep." *Archaeology,* November/December, 41(6):20–27.

Printseva, M.N.

1983. "Pamiatniki melkoi mednolitoi plastiki v sobranii Gosudarstvennogo muzeia istorii religii i ateizma." *Nauchno-ateisticheskie issledovaniia v muzeiakh* [Science and Atheism Research in Museums, a Collection of Scientific Works Published by the Ministry of Culture, RSFSR, Government Museum of the History of Religion and Atheism (GMIRiA)], pages 35–49. Leningrad.

1986a. "K voprosu ob izuchenii staroobriadcheskogo mednogo lit'ia v muzeinykh sobraniiakh." *Nauchno-ateisticheskie issledovaniia v muzeiakh*, pages 47–68. Leningrad. [See Printseva, 1983 for bracketed statement.]

1986b. "Kollektsiia mednogo lit'ia F.A. Kalikina v Sobranii Otdela istorii russkoi kul'tury Ermitazha." In *Pamiatniki kul'tury - Novye Otkrytiia 1984 [Yearbook of the Academy of Sciences of the USSR]*, pages 396– 407. Leningrad: Nauka.

Ryndina, A.V.

1978. *Drevnerusskaia Mel'kaia plastika, Novgorod i Tsentral'naya Rus' XIV-XV v.* Moscow: Nauka.

Sedova, M.V.

1966. "Novgorodskie Amuleti-Zmeeviki." *Kultura Drevnei Rusi.* Moscow: Nauka.

Simpson, Rev. W.S.

1867. "Russo-Greek Portable Icons of Brass." *The Journal of the British Archaeological Association*, pages 113–123.

Teteriatnikov, V.

1977. "Mednye kresty i ikony v narodnoi zhizni." *Novyi Zhurnal*, 129(December):155–170. New York.

Tolstoy, Count I.I.

1888. "O russkikh amuletakh, nazivaemykh zmeeviikami." *Zapiski Russkago Arkheologicheskago Obshchestva*, 3:363–394. St. Petersburg.

Zenkovsky, Serge A.

1976. "Staroobriadtsy tekhnokraty gornogo dela Urala." *Transactions of the Association of Russian-American Scholars of the USA*, 10:153–181.